BETA TANK

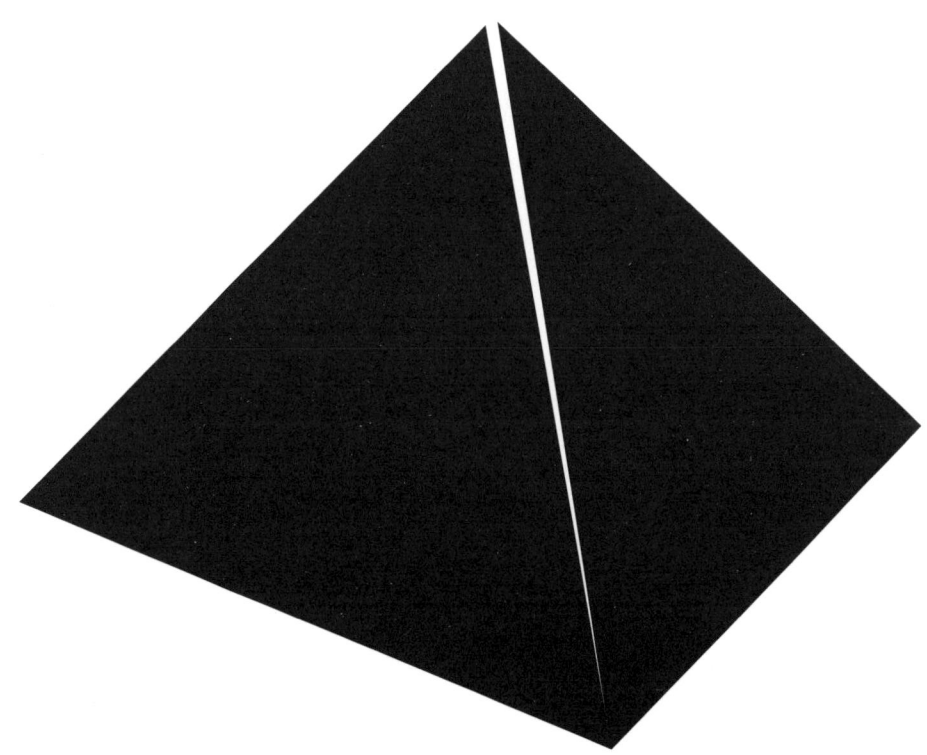

TAXING ART
When Objects Travel

gestalten

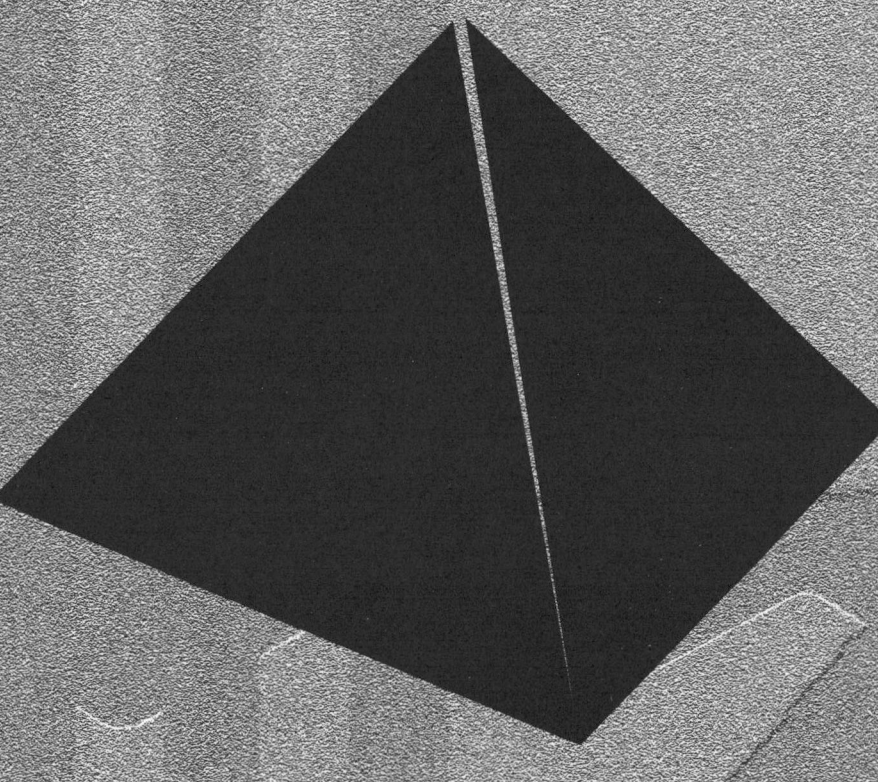

TAXING ART
When Objects Travel

TAXING ART

Table of Contents

004 Introduction

006 The Designer Beta Tank

008 Working in Berlin

012 Taxes in Berlin / The Accountant

013 VAT and Import Duties

015 Chapter 97

016 Works of Art, Collectors' Pieces and Antiques

018 What is Art?

021 Design-Art

024 Taxing Objects

031 Chanimals

040 Box of Loose Hammers

052 T–228/89

064 Designers of the Future Award

074 Transportation

078 Avoiding Switzerland

082 Berlin to Basel

099 W Hotels Designer Tour

100 Berlin to Barcelona

110 Back in Berlin

124 Berlin to Istanbul

132 Istanbul to Doha

144 Back in Berlin Again

152 Conclusion

156 Appendix The Journey Numerical / Index

160 Imprint

INTRODUCTION

Introduction

Taxes never really interested me. It was usual for my company in the U.K. to show a loss at the end of

the year, so invoices and receipts were not a big part of my work life. It was only when my career developed that the business had to become more organized. Running a profitable niche design practice is no small feat and taxes play a far more decisive role in the practice's success than it does in a normal business.

So how did I begin to make objects that confronted German tax laws and send them around the world in the hope that they would get stopped at customs?

This book charts that journey, which began with conversations with my bookkeeper in Berlin and ended with an exhibition in the deserts of Qatar.

BETA TANK

Fig.1

The Designer

I was born in 1977 in the suburbs of Tel Aviv. In 1986 my parents permanently relocated our family to London, where I lived until 2009 when I moved to Berlin.

Beta Tank

I began Beta Tank, a conceptual product design practice, directly after my graduation from the Royal College of Art. Each project at Beta Tank is self-initiated, with research used only as a starting point—a project's end is never known. What I do know is that I like to leave a trail of objects behind and whenever I come to a realization, I like to encapsulate that realization in an object—a kind of physical place marker for my thoughts.

Beta Tank's first project, *Sensory Substitution* (2008), looked at human visual perception and how and why we see things. Paola Antonelli, who was putting together the "Design and the Elastic Mind" show at the Museum of Modern Art in New York City, was a supporter of the project and eventually invited Beta Tank to participate in the exhibition. We made a series of objects for the MoMA exhibition utilizing a technology that allows the brain to receive images from senses other than the eyes. These lollipop-shaped objects contain a USB connecter that enables a person to download an image onto the lollipop, using it to see with their tongue.

Taxing Art is Beta Tank's second project. Unlike *Sensory Substitution*, it started as a commission for Design Miami / Basel 2010.

Fig.1 The *Thought Bubble*, an object commissioned for the Deitch Art Parade in New York in 2000, which was canceled due to Hurricane Hanna.

Fig.2 A model of the *Eye Candy* lollipop, which puts images in the mind using sensors on the tongue. This object is now in the permanent collection at the Museum of Modern Art in New York.

WORKING IN BERLIN

Fig.1

Working in Berlin

When I decided to relocate from London to Berlin, I was in for a shock; in comparison to the laid back business attitude in the U.K., Germany has extremely tight regulations and controls in place.

In Germany a person can only work as a freelancer if they are working for more than one client. Also, health insurance is compulsory and costs between 200 € and 300 € a month for a healthy 30 year old.

A robust legal framework ensures a high standard of German business ethics. Every service provider, for example, is required to be transparent about who they are and accountable for what they provide, resulting in the Impressum page on German websites which contains detailed information about the people behind the advertised service. During my first year in Berlin I refused to register Beta Tank as a German company; it was just too hard to communicate with the authorities. But after a year, I had no choice; it was required by law.

This business environment produces a surprisingly relaxed attitude towards money—but the downside is that most companies are unwilling to produce anything outside their comfort zone or anything with a tight deadline. For Beta Tank this situation is a nightmare; every Beta Tank project involves producing unique objects and that requires imaginative flexibility from manufacturers. There is only one art fabricator in Berlin. Unfortunately its prices are too high for fabricating design objects. The exception to this is a metal workshop in Berlin-Wedding called Uzuner Edelstahlverarbeitung who are extremely accommodating and produce high quality and complicated objects for us.

Fig.1 The *Mind Chair Polyprop* uses sensory substitution technology in an attempt to visualize the potential for this technology to be used in an everyday environment, such as a classroom. On this particular project, Beta Tank collaborated with Peter Marigold.

8

TAXING ART

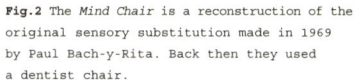

Fig.2 The *Mind Chair* is a reconstruction of the original sensory substitution made in 1969 by Paul Bach-y-Rita. Back then they used a dentist chair.

Fig.2

WORKING IN BERLIN

TAXING ART

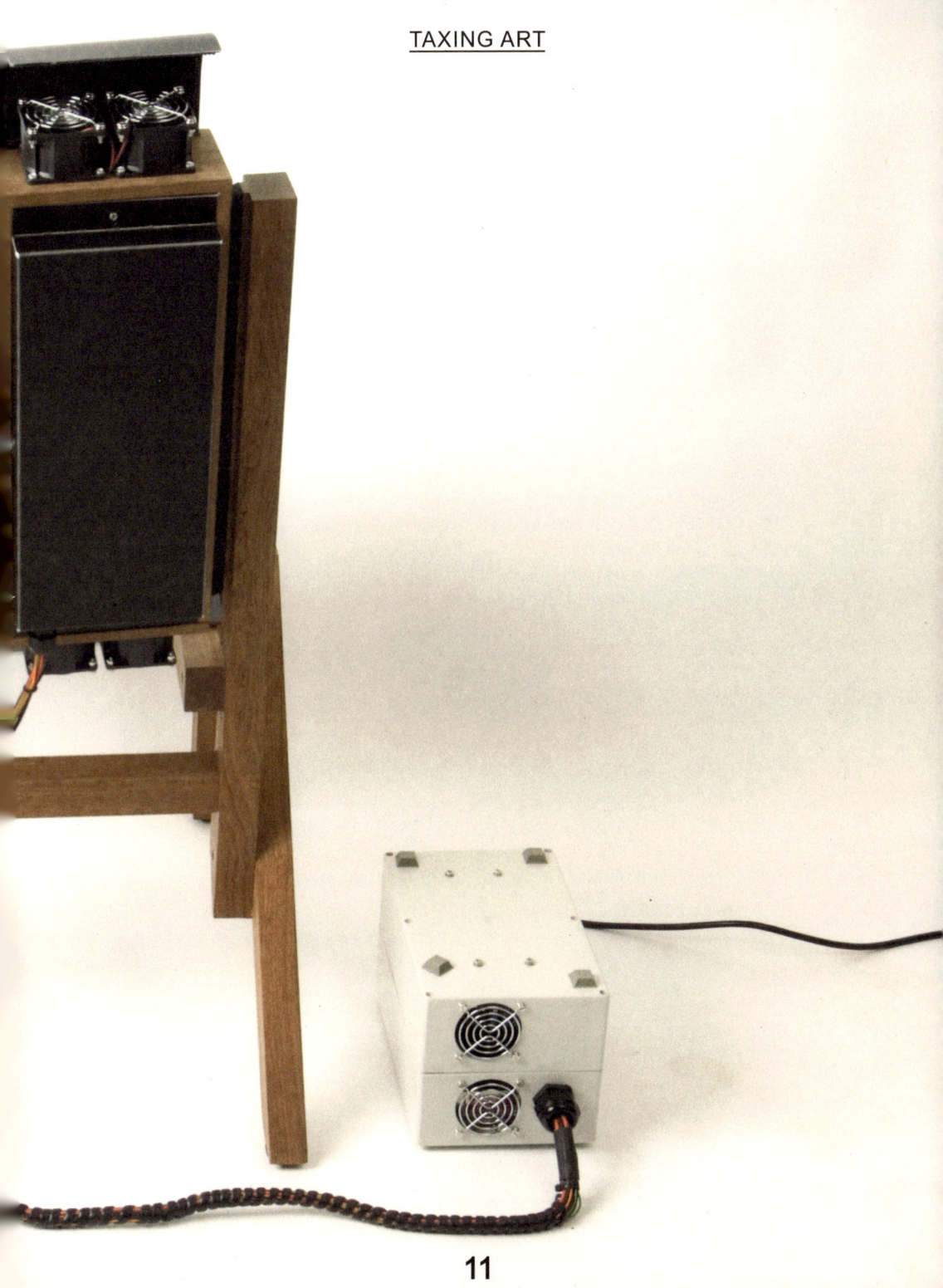

Taxes in Berlin

Ultimately there were many little events—conversations, arguments, assumptions, interpretations, and misunderstandings—that lead me to take a closer look at taxes.

In London I spoke with my accountant about four times a year but in Berlin we had weekly chats—and of course one really big chat towards the end of the month because I had to pay the previous month's Value Added Tax, or VAT, meaning that the entire accounting needed to be done every month.

I have acquired an appreciation for this monthly system. I am, for instance, able to remember exactly what receipts were for rather than trying to remember why I purchased something a year ago. At the beginning, however, my former business partner, Michele Gauler, was in charge of the bureaucratic section of the company and I was left out of the conversations between the accountant, bookkeeper, and our local tax authority. I did, however, learn about what fines we had to pay, which objects we purchased that were not accepted as expenses, and the monthly costs of accounting. All of this created friction in the company; we were making the same type of objects in Berlin that we had made in London, but for some reason we were having a harder time with the authorities.

It was Michele who realized that the tax system is more than just a nuisance—it is a very interesting phenomena that represents German culture and assumptions about fairness and competition.

UNESCO has appointed Berlin—as the first city in continental Europe—to the Creative Cities Network under the framework of UNESCO's Global Alliance for Cultural Diversity.

In January 2006, the United Nations' organization for education, science, culture, and communication will award Berlin the title of "City of Design."

The Accountant

The accountant plays a large (and sometimes quite expensive) role in almost every business in Germany. A couple of years ago, as part of a Camper store pitch in Berlin, I went into a Camper store and bought a pair of shoes so that I could get a sense of the rhythm in the store and experience the service. The shoe was then used as a prop in the photo shoot for the pitch presentation. I was not successful in getting the pitch, but I handed in the receipt for the shoes to my bookkeeper. A couple of days later I received a call from my accountant asking me in detail about the shoes. It was obvious that I couldn't just expense any purchase, but even after explaining their use, I could not convince my accountant that the shoes would not be used by me at some point in the future. Because of this they would have to be entered into the company accounts as an owner's loan of shoes to the company. This taught me that it made sense to speak with the accountant before making a new object.

Beta Tank produced a series of objects called *Memory*

Beta Tank's accounting bill ranges from 5% to 10% of its monthly turnover, a figure that is similar to many freelance designers in Berlin.

TAXING ART

Stücks for the 2009 DMY Berlin Design Festival. These objects were equipped with USB sticks that carry their digital memories. The *Memory Stücks* are individual, handmade, and limited in quantity. Our accountant informed me that they must be sold at a 7% VAT rate—a fact that had more implications than I initially thought.

It is very difficult to find an English-speaking accountant in Berlin and the tax authorities do not like it when you hand in receipts from clients that are written in English.

I would love to say that my understating of this subject has improved greatly and that by researching this topic I have found solace in the knowledge that there is some sense attributed to how goods are classified and taxed. Frankly, I found it much simpler to grapple with neuroscience and the issues surrounding perception than to decipher the almost endless amounts of information, rules, and annexes in the world of taxation. I want to make it clear that I am by no means qualified to explain these concepts. I am simply discussing the problems faced when running a creative business inside the European Union, as I understand them; I still constantly ask my accountant for VAT advice.

VAT and Import Duties

The EU VAT Directive, the common VAT framework set up by the European Union, must be followed by all EU member states. In broad terms, it allows for two rates of VAT: a reduced rate and a normal rate. The reduced rate must not be less then 5% and the normal rate must not be less then 15%. Within this framework, each country is free to apply these rates at their discretion. In Germany, for example, works of art purchased directly from the artist incur the reduced 7% VAT rate.

The U.K. negotiated with the EU to enable art sold in the U.K. to be charged at 2.5%. Consequently, the U.K. accounts for 40% of all the EU art sales.

The framework was set up to insure that competition is maintained between the EU member states but on an international level things are very different; every country has different import duties and it is not easy to find out what the rates are. The Harmonized Commodity Description and Coding System (HS) is the one uniting factor for about 150 countries. It is a list of roughly 10,000 entries that cover between 50 million to 100 million goods. It has the legal status of a convention and has been in effect since January 1, 1988. It does not mean that all these countries have common tariffs—it just means that they at least all agree on the goods classifications.

nomenclatura "calling of names," from nomenclator "namer," from nomen "name" + calator "caller, crier," from calare "call out"

In turn, the EU has a list called The Combined Nomenclature (CN), which is taken in full from the HS list. I became very familiar with this list while working on this project. Each time I exported my objects they would change from one classification to another. As I moved from Europe through Asia and then to the Middle East, the classifications became exceedingly confusing.

13

CHAPTER 97

Fig.1 *USB Chair*, part of the *Memory Stücks* project is an everyday object fitted with a USB stick loaded with the objects memories.

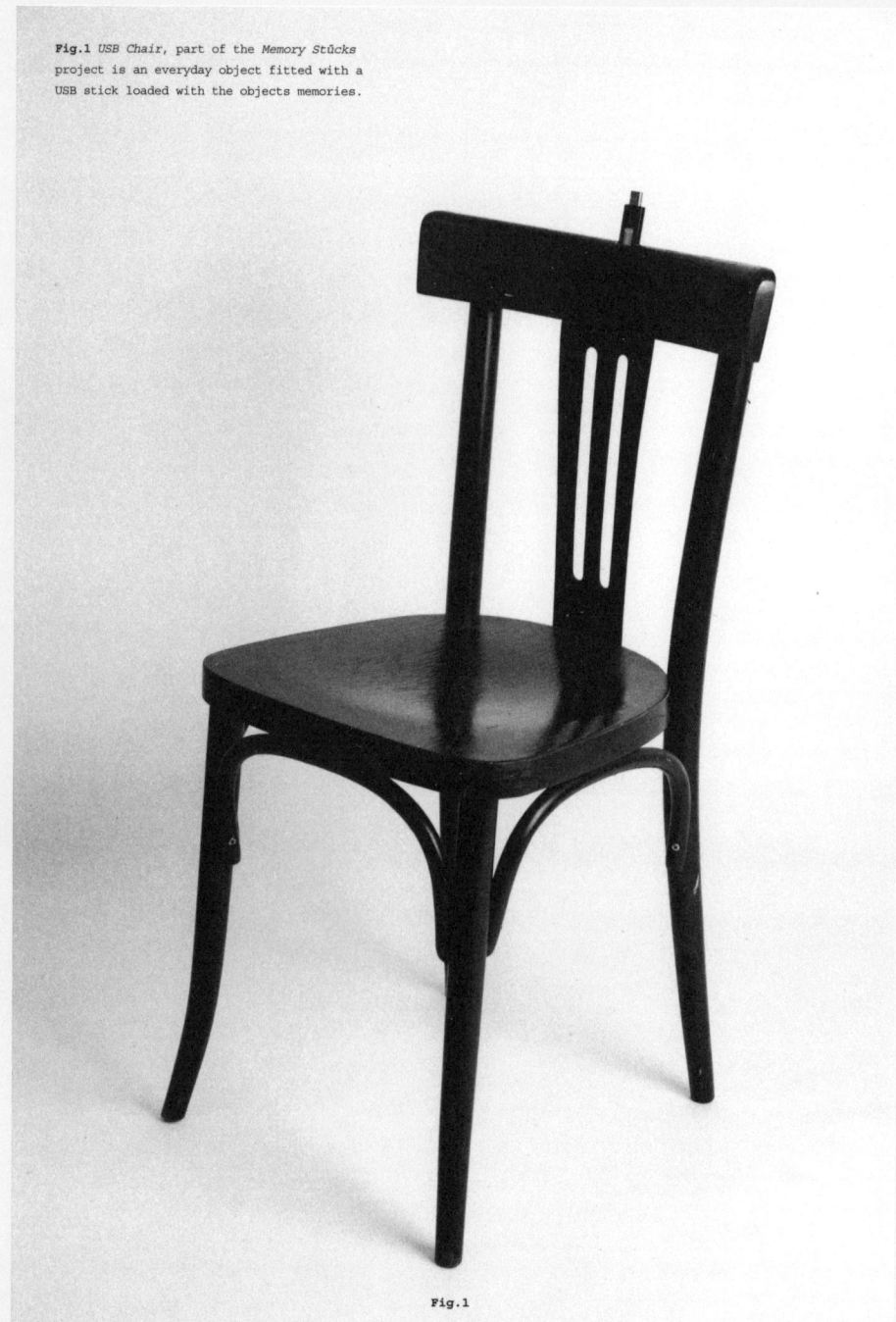

Fig.1

TAXING ART

CHAPTER 97

Notes

01. This chapter does not cover:
 (a) unused postage or revenue stamps, postal stationery (stamped paper) or the like, of heading 4907;
 (b) theatrical scenery, studio backcloths or the like, of painted canvas (heading 5907) except if they may be classified in heading 9706; or
 (c) pearls, natural or cultured, or precious or semi-precious stones (headings 7101 to 7103).
02. For the purposes of heading 9702, the expression "original engravings, prints and lithographs" means impressions produced directly, in black and white or in color, of one or of several plates wholly executed by hand by the artist, irrespective of the process or of the material employed by him, but not including any mechanical or photomechanical process.
03. Heading 9703 does not apply to mass-produced reproductions or works of conventional craftsmanship of a commercial character, even if these articles are designed or created by artists.
04. (a) Subject to notes 1 to 3 above, articles of this chapter are to be classified in this chapter and not in any other chapter of the nomenclature.
 (b) Heading 9706 does not apply to articles of the preceding headings of this chapter.
05. Frames around paintings, drawings, pastels, collages or similar decorative plaques, engravings, prints, or lighographs are to be classified with those articles, provided they are of a kind and of a value normal to those articles.
 Frames which are not of a kind or of a value normal to the articles referred to in this note are to be classified separately.

CN Code Description Supplementary Unit

9701 Paintings, drawings, and pastels, executed entirely by hand, other than drawings of heading 4906 and other than hand-painted or hand-decorated manufactured articles.

Collages And Similar Decorative Plaques:

9701 10 00	Paintings, drawings, and pastels
9701 90 00	Other
9702 00 00	Original engravings, prints, and lithographs
9703 00 00	Original sculptures and statuary, in any material
9704 00 00	Postage or revenue stamps, stamp-postmarks, first-day covers, postal stationery (stamped paper), and the like, used or unused, other than those of heading 4907
9705 00 00	Collections and collectors' pieces of zoological, botanical, mineralogical, anatomical, historical, archaeological, palaeontological, ethnographic, or numismatic interest
9706 00 00	Antiques of an age exceeding 100 years

CHAPTER 97

Works of Art, Collectors' Pieces and Antiques

Of the 10,000 entries in the Harmonized Commodity Description and Coding System, there is one category that I find very interesting.

It is the much debated Chapter 97, which deals with art. On the HS list, almost every imaginable object exists, from metal brushes to MDF tiles, but the entire art world has been reduced to six entries, all contained in Chapter 97.

Most entries in the HS list have very short notes attached to them—if any. But as you can see here, there are more notes in Chapter 97 than there are entries. It is a contentious subject because authorities and other government institutions want to avoid making decisions on what constitutes art. On the other hand they fear that if the definition of "art" is too vague, every manufacturer will claim their goods as art in order to receive reduced VAT rates and customs exemptions.

The list of entries describes an almost archaic notion of art, one that would certainly exclude most contemporary artists. There is one entry, though, that redeems the list and allows most art to be included: 9703. Roughly translated it means that a three-dimensional object in any material can be considered as art. In theory that code should be broad enough to contain new forms of expression—even ones yet to come.

Chapter 77 of the Harmonized System is reserved for future international use.

There is a note attached to entry 9703 that has some very interesting implications: it says that artwork must not have any commercial characteristics. At first I thought the reason for this had to do with a concern that manufacturers would start claiming, for example, that the popular garden gnomes were works of art. Instead, governments are worried that artists will have a competitive edge with goods similar to commercial goods, which would consequently have a negative impact on manufacturers. The implication is that art may not be functional—it cannot even have the appearance of functionality. Tax authorities want to make it very clear that design and craft is not included in the artist member's club. This means that almost every piece I make is considered to be commercial and is taxed at the full rate with conventional import duties levied when moving these objects between countries.

Out of 135 countries, 125 have signed the HS code.

Governments clearly need to generate revenue. In fact, half of the German budget comes from customs fees. Although I understand that governments need to make money, I think it should be much easier to determine if a form of expression qualifies for tax assistance or not.

16

TAXING ART

Fig.1 Beta Tank, Spazio Fendi, Milan 2010, allowed visitors to engage with concepts and ideas Beta Tank developed from two years of researching perception with the support of Dr. Beau Lotto of UCL.

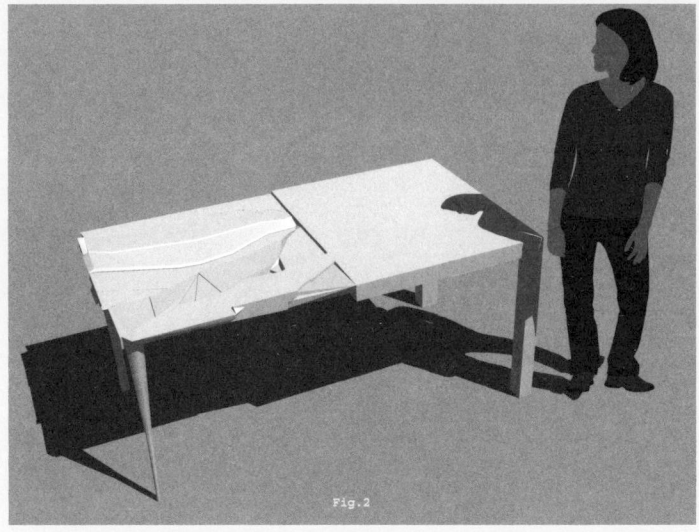

Fig.2 The *B-Side* table is based on the ubiquitous IKEA table series called LACK. It is a commissioned piece by Dilmos, a gallery in Milan, Italy.

What is Art?

A German Tax Advisor Explains,
by Barbara Putz,
translated by Shirah L. Wagner

What is art? Who is an artist? What does this have to do with the taxation law?

Article 5, Paragraph 3, Sentence 1, Basic Law guarantees the freedom of art. The problem is defining art as a legal concept and clearly defining its barriers. In the so-called Mephisto Decision, the constitutional court had an opportunity to further narrow the concept of art. An artistic activity distinguishes itself by being a free creative composition, in which impressions, experiences, and the experiences of the artist are brought to the immediate view, through a medium. It plays no role with which objective the activity occurs or the ultimate purpose of the art piece.

Article 5, Paragraph 3, Sentence 1, Basic Law authorizes the State to promote the arts and favor them in taxation laws.

There is no general definition of art in tax law. This leads to the fact that artists must have a consultant who has to qualify their activities as artistic ones. The tax authorities are not bound to the consultant's opinions, but as a rule they use these opinions as something by which they orient themselves.

TAXING ART

The impacts of the income tax law are essential for the classification of the activity: is the activity independent or dependent? Is the independent activity freelance or commercial?

The activity is commercial if the products are multiplied and introduced to the market. This is also the case if an employer of the artist engages too much in the production, so that the artist creates objects following the customer's instructions only.

The federal finance court then decides that an activity is artistic if the works of the tax payer are the payer's own creation, and if that creation achieves a sufficient mastery of art beyond a certain artistic design height.

Photography is generally not an artistic activity. The choice of motive and the design are not enough to establish photography as an artistic activity. In isolated cases, photographs may be works of art, as long as they go beyond the reproduction of reality, either on account of the artist's own motive or on account of utilizing photographic technology for the purpose of the artist's own statement portrayed in the picture. Even with artistic takes, one has to check whether the whole activity seems nevertheless commercial because of other works of photomechanical types and extensive lab operations. The question is whether these demarcations violate the equality principle according to Article 3, Basic Law.

The artist bears the burden of proof for his artistic activity and must prove this with an expert's certificate if necessary.

A distinction was made between free art, art trade, and art craft by the jurisdiction. Under these distinctions, free art is completely useless and has no practical purpose. It is directed exclusively to produce an aesthetic effect. Overall, it is an intrinsically creative activity that has reached a certain level of artistic design.

Art trade and art craft are linked with purposeful art and a practical utility value.

Artists attain income from independent work. After constant jurisdiction from the federal finance court, an artistic activity is recognized if the characteristics are subjective, as well as objective. Criteria for the presentation of artistic traits are, for example:

- The training provided by a college of art, academy of fine arts, craft school, or crafts art school

- Art prizes and awards received

- Substantial artistic achievement

- Criticism in reputable newspapers and art magazines about the participation in art exhibits

- Membership in certain professional organizations, such as the *Künstlersozialkasse* (Artists Social Fund.)

The classification of an artistic activity is associated with considerable uncertainties. This can be seen recently in connection with new mediums.

It also raises the question of how self-taught artists are classified in this legal world of formal divisions. According to the stringent compliance of the above-mentioned criteria, these people can never be artists.

DESIGN ART

Fig.1

Fig.1/2 *The Flower* and *The Comb* examine how we would live and interact with nanoparticles if they were to be freely dispersed in our environment. In our everyday experiences this technology would have the physical characteristics of fine dust.

Fig.2

TAXING ART

Fig.3

Design-Art

Fig.3
The *Access Key* allows friends and family to remotely log on to the digital remains of those who are deceased.

Design-art is a relatively new addition to the art and design scene and it borrows from both disciplines. Practiced mostly by designers, it strays from the design convention by taking more than form and function into account.

There are only two design-art galleries in Berlin.

The project *Digital Remains*, created by my ex-business partner Michele Gauler, looks at the digital legacy we leave behind and what happens to that information once we die. This is a design research project and points towards future services and aesthetics. There are no plans for this object to be mass-produced in the near future. Therefore the object is not a work of art, nor is it a working prototype. I mention this project to show how interesting and important this type of work can be; the progress made by industry alone would leave our object landscape generally unchanged and uninspired.

A much more futuristic approach to this practice is *The Flower, Fossils From a Nano-tech Future*, a project by James King. In it he designed an object to be used as a personal air filtration system. This project takes design research into the future—much further than any research done by commercial industry. In this project, the role of the designer has expanded; designers no longer only provide a service but also initiate important work and create culturally important objects. This is a development similar to what happened when artists no longer only provided a service but began to create work according to their own agenda.

My own work is obviously not the product of mass production, nor is it work of any current significance to manufacturers. It does, however, have commercial characteristics that may give the impression of a product, keeping it outside the classifications that would allow it to benefit from lower VAT and customs rates. This creates a difficult business environment for this type of enterprise.

Producing design-art objects on a large scale usually only means 200-400 objects sold worldwide.

21

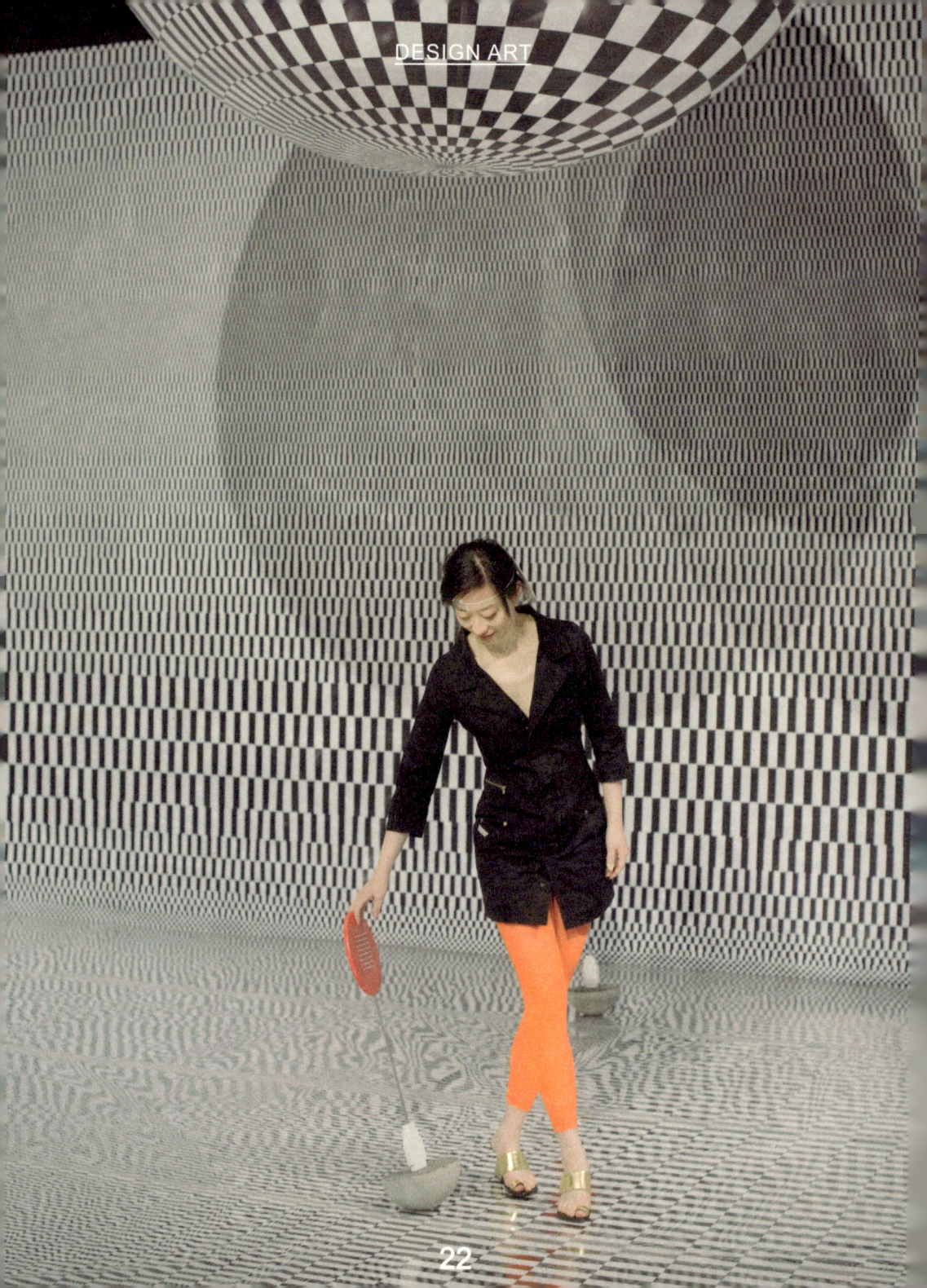

TAXING ART

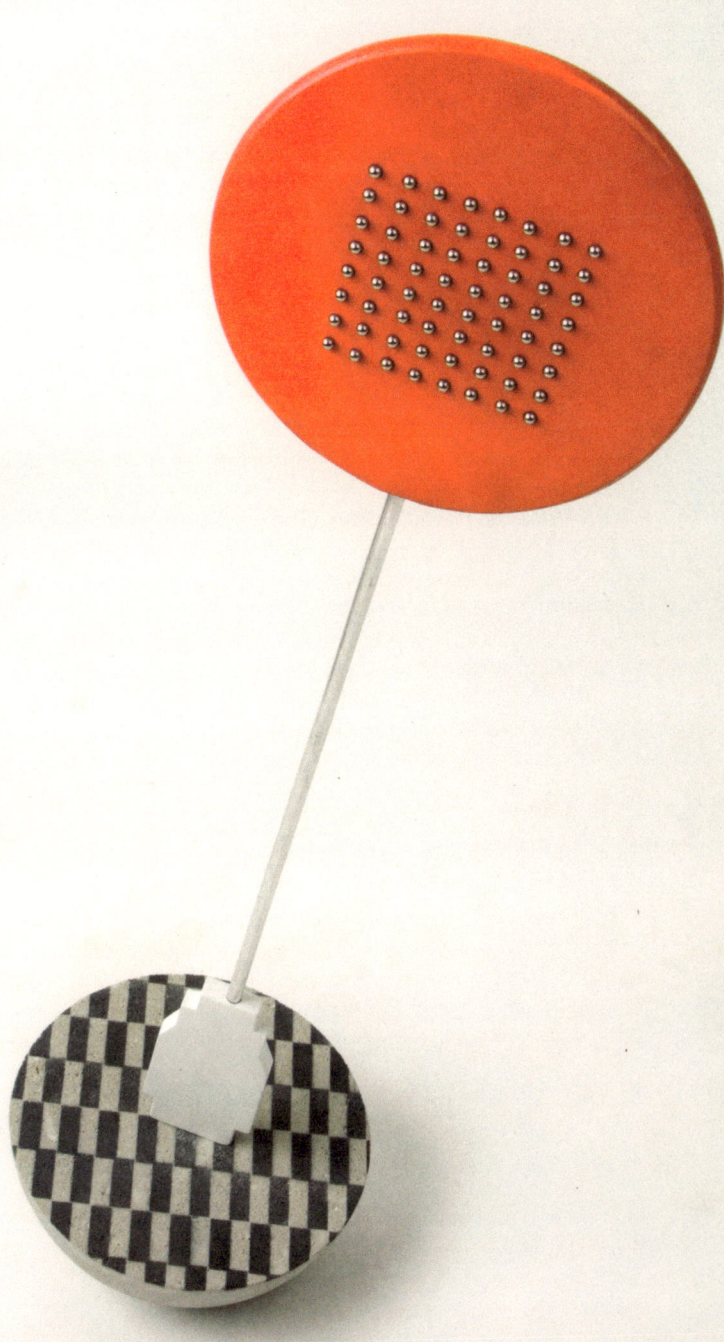

Fig.1 Fig.2

Taxing Objects

In April 2010 Beta Tank received the W Hotels' Designers of the Future Award and a commission to create a project for Design Miami/Basel in June 2010. For the commission I decided to make objects that dealt with the effect of taxation on my practice and started to properly look at the rules and laws that had always felt so stifling to my practice. It was also a chance to send these objects to a country such as Switzerland, which is not a full EU member.

My research is mostly anecdotal. I make objects as a way to help me get into a project; the first objects I make are experiments rather than finished pieces. Part of the question as to whether something should be classified as art or design has to do with the quantity of objects produced and the way in which they are made. However, it is not clarified anywhere in writing at what number an object becomes mass-produced. It is also unclear what constitutes "handmade." These problems are not an issue with classic works of art and this makes design-art difficult to quantify in legal terms. Tax officers and customs officials are left to spontaneously decide for themselves when an object is presented to them.

Fig.1/2 The images are pictures of the *Lollipop Tumbler*, a prop used in the Beta Space installation. These would sway as the *Thoughts Bubbles* collided with them.

The first sketches I made for *Taxing Art* were of a dining room table. Half of it was to be made by hand, the other half with standard manufacturing techniques. The two halves would be manufactured separately and then sent directly to the exhibition, where they would be assembled on-site to make one hybrid table. During this time I came across the trial of Farfalla Flemming, who were taken to court by the tax authorities in Munich, Germany in 1989. The trial concerned an edition of glass paperweights that a recognized artist had produced in a limited edition. The tax authorities would not allow the glass spheres to be classified under Chapter 97 and asked for the European Court of Justice to make a ruling. Farfalla Flemming lost the case and were asked to sell them at the normal VAT rate instead of the reduced rate. It was this case that taught me about competing goods and the role functionality plays in whether an object can be considered art. In Farfalla's case, the judge was concerned that because the paperweights had commercial characteristics, classifying them as sculptures would allow Farfalla Flemming to sell the paperweights at the reduced rate, giving them an unfair commercial advantage over other paperweight manufacturers.

Even 23 years after this trial, none of the parties mentioned wanted to make any formal statements on this matter.

TAXING ART

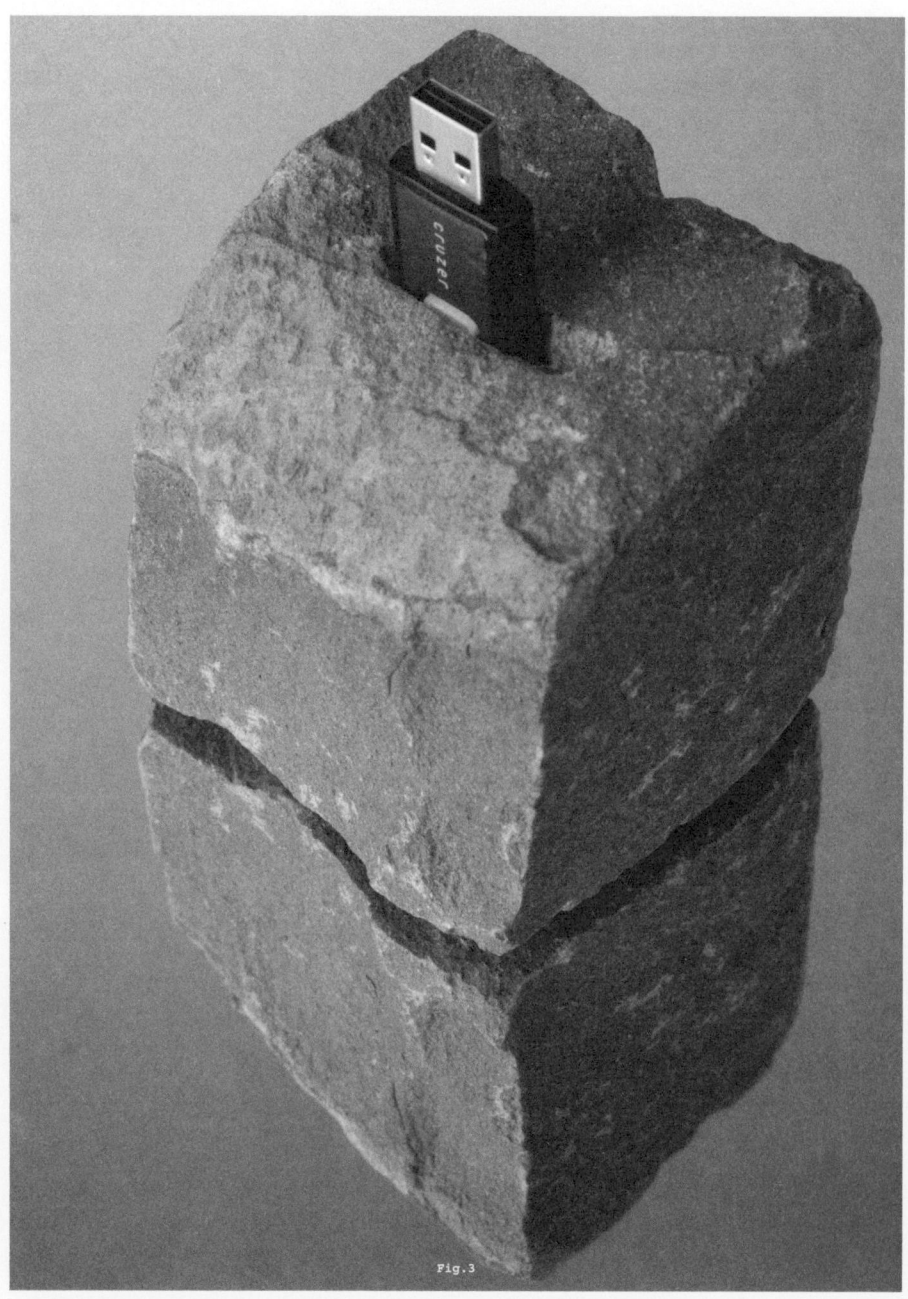

Fig.3 The *USB Stone* is part of the *Memory Stücks* project; each stone carries memories of its past.

TAXING ART

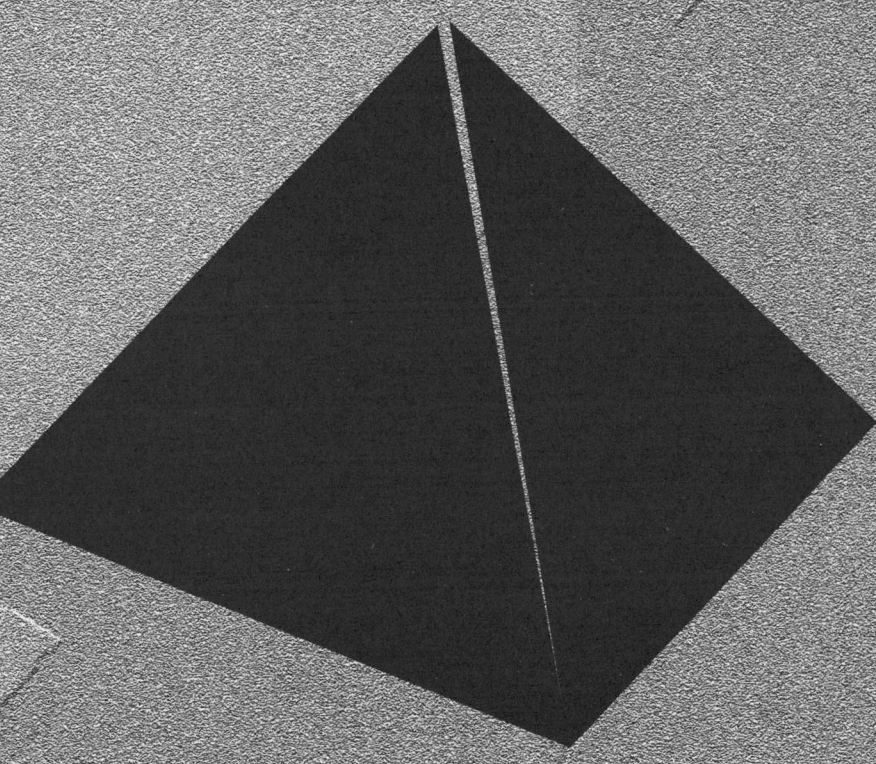

TAXING ART
When Objects Travel

CHANIMALS

TAXING ART

While I was working on the *Pyramid Table*, Michele was working on a bench made from 160 acrylic profiles shaped like a chair. Each profile was slightly different with the angle of the seat corresponding to the rate of VAT charged; the 90 degree profile would receive the 19% VAT and the 45 degree profile would recieve the 7% VAT. A bench with very limited functionality is created when all the pieces are combined, creating an unofficial chair scale. This prompted a number of questions such as at what angle does the chair profile turn into a random shape and thus become art? The bench not only responded to the issue of functionality but also how items are presented to tax and customs officials.

CHANIMALS

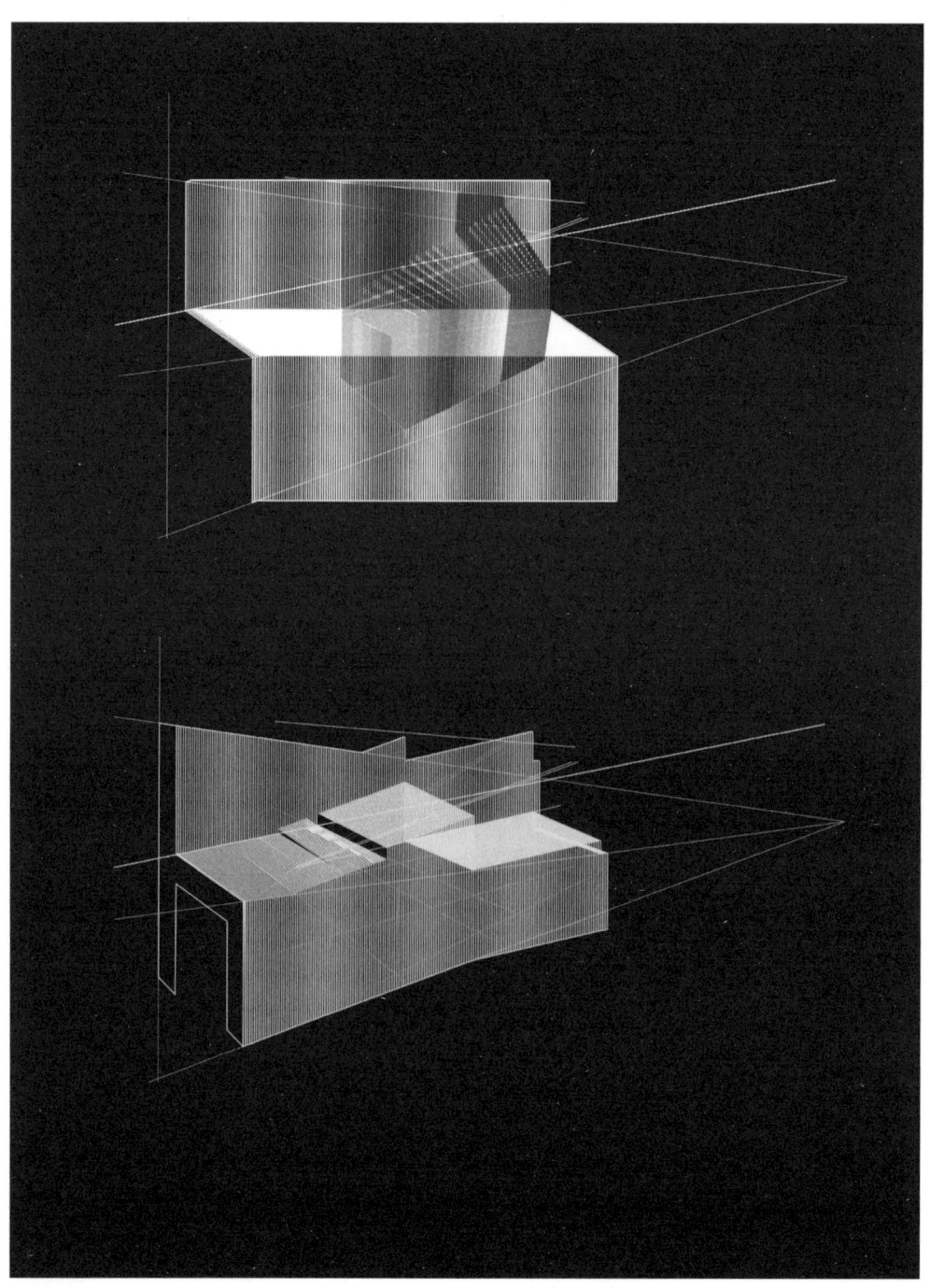

TAXING ART

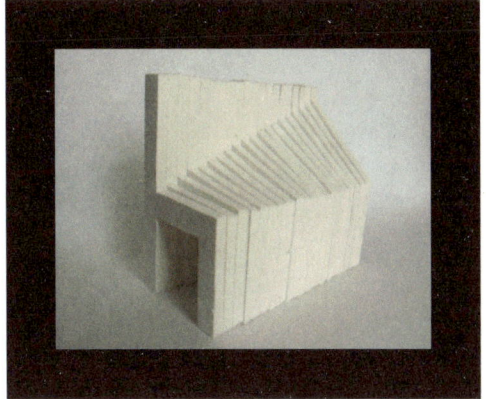

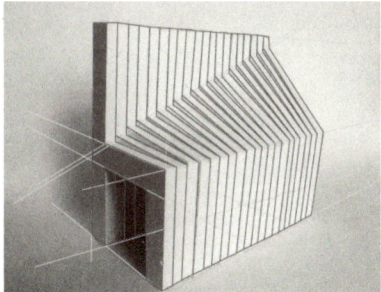

Chanimals

In an appeal case raised by the U.K. gallery Haunch Of Venison, artists Dan Flavin and Bill Viola had pieces classified as electrical goods and audio equipment, respectively. At the time of inspection, Her Majesty's Commissioners Of Revenue and Customs claimed that it was the constituent parts that were being classified; the gallery had won its appeal. But in more recent times the European Court of Justice has overturned this ruling and a separate annex has been added to the Combined Nomenclature list ensuring that if light and sound installations travel in parts they will not be classified as art for tax purposes.

The bench profiles, seemingly functionless on their own, would be crossing the border in separate profiles. For the Basel exhibition it was decided to simplify the bench and instead create self-standing metal extrusions at the beginning, middle, and end of the bench. The "chair animals" marked three points along the design-to-art scale, going from usable to uncomfortable to an abstract sculpture.

CHANIMALS

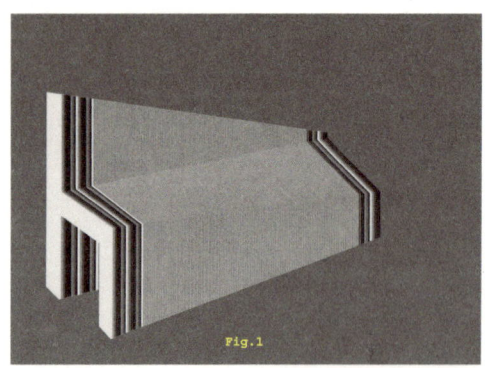
Fig.1

Fig.2

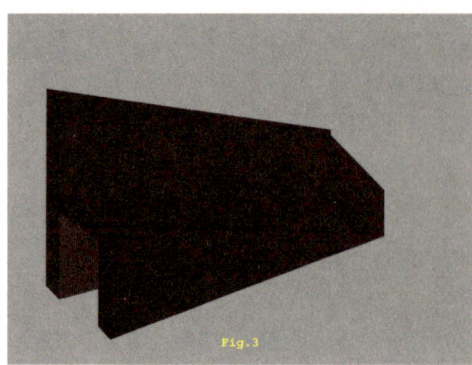
Fig.3

Fig.4

Fig.5

Fig.6

TAXING ART

Fig.7

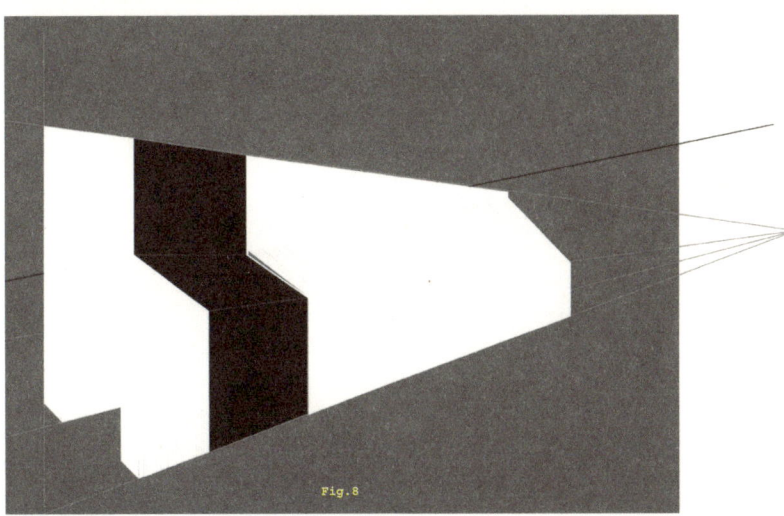

Fig.8

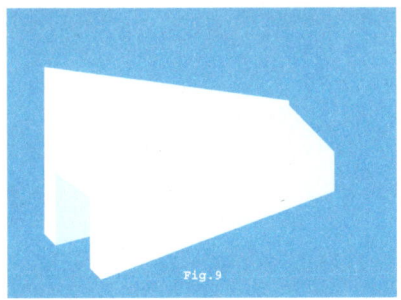

Fig.9

Fig.1-9 These different experiments with color were made by Michele Gauler in order to find the best way to emphasize the change from design to art. As in all our projects, we never make prototypes because there isn't a sufficient budget for testing. Once a sketch is approved, it is sent to be manufactured.

CHANIMALS

TAXING ART

CHANIMALS

Fig.1-5 The images are from the metal workshop in Wedding, Berlin. The objects were made by welding steel sections together to make a hollow shape, 160 cm wide.

Fig.1

Fig.2

TAXING ART

Fig.1-5 Each of the three shapes was powder-coated in pastel colors from the RAL color profile system. The objects are both self-standing and meaningful in their own right and created to form a set.

CHANIMALS

Fig.1

TAXING ART

Fig.1/2 The *Tax Bench*, with its original intention, has been commissioned by Adidas, Y-3. Slightly modified, it will be on show at the Y-3 exhibition in Milan, Italy during the 2011 furniture fair. The 2.5 m bench is made from 160 individual 20 mm acrylic profiles. These are attached by magnets, which are embedded in the plastic. The bench itself must be sold at 19% VAT, but the profiles are sold at 7% VAT. This bench is also customs-proof and under inspection by customs authorities, although its noncommercial classification is accepted.

Fig.2

Box of Loose Hammers

This coffee table is one of my favorite objects. It is simply a box with a 100 loose hammers inside. It is made of clear epoxy and is an exact cast of a normal packing box. I always wanted to know if calling an object something other than its original name would change its tax classification. The box is transported with 100 hammers inside and is literally a box of loose hammers. Would the person inspecting it question the box's real use because it was made of epoxy instead of cardboard?

The hammers themselves played a local role because just like every other expense, my bookkeeper asked me to justify buying them. In fact, after I bought ten hammers my bookkeeper asked me if I was planned to resell them because if I did, not only would there be a 19% VAT, but also an additional 3% trade tax.

TAXING ART

BOX OF LOOSE HAMMERS

These are the first sketches
sent to the Design Miami team
before the show at Basel 2010.

TAXING ART

43

BOX OF LOOSE HAMMERS

TAXING ART

BOX OF LOOSE HAMMERS

Fig.1

Fig.2

Fig.3

Fig.4

Fig.1-8 The final box used was a tattered and old moving box found in the Beta Tank studio. The box still had all of the masking tape and address labels on it. As the epoxy hardened, the sections that were cast directly from the cardboard had a matt finish, while the sections cast directly on the tape or the labels had a super glossy finish. The epoxy picked up every little detail and even the address label is still completely legible.

TAXING ART

Fig.5

Fig.7

Fig.8

BOX OF LOOSE HAMMERS

Fig.1

Fig.2

Fig.3

Fig.4

TAXING ART

Fig.1-8 The *Box of Loose Hammers* was intended to be a coffee table. The images are of both shoots— one in a gallery setting and the other in a domestic environment.

Fig.5

Fig.6

Fig.7

Fig.8

49

BOX OF LOOSE HAMMERS

TAXING ART

T-228/89

My first attempt to make a design object that could swing from functionless to functional began with reworking this half handmade, half industrially manufactured table.

I decided to split the two concepts into separate objects, each dealing with a single issue; one table would deal with functionality in art and the other with the manufacturing process of the object.

TAXING ART

T-228/89

TAXING ART

Designing a functioning dining table that can also transform into a sculpture quite easily got me thinking of very simple hinges, a simple axel that the user can quickly touch or swipe and effect the table's form. To make the *T228/89* table (named after the Farfalla C T228/89 court case, which inspired its making), I used full steel profiles to make 119 squares, which were perforated to house axels and magnets to stop the pyramids from spinning freely.

The table now has two states: one in which the tops of the pyramids are pointed down and resembles a complete functioning table and one in which the pyramids are up and the table is a sculpture.

I wanted to transport it across the border to the exhibition in Basel with all the pyramids pointed up in order to classify the object as a sculpture.

T-228/89

TAXING ART

T-228/89

Fig. 1

Fig. 2

Fig. 3

Fig. 4

TAXING ART

Fig. 5

Fig. 1
A water jet cutting machine quickly going through large steel plates that are 20 mm thick.

Fig. 2
The powder coating facility where the 150 kg table was hung upside down and sprayed.

Fig. 3
The steel profiles were cut in order to fit together like a puzzle.

Fig. 4
Each profile was then welded to create a grid.

Fig. 5
The finished table was wrapped up and placed directly in the van that would be used to drive from Berlin to Basel.

Fig. 6
A final polish was given to the table to prepare for the powder coating.

Fig. 6

59

TAXING ART

Fig.1-3 The *B-side* table is a smaller version of the first sketch I made when thinking about making objects that challenge German tax laws. The half IKEA-like table is joined with a hand-carved wooden half, creating a tax hybrid object. The construction of the table was commissioned by Dilmos in Milan and will be on show there during the 2011 furniture fair.

Fig.1

TAXING ART

Fig.4

Fig.3

DESIGNERS OF THE FUTURE AWARD

DESIGNERS OF THE FUTURE AWARD

The committee of Design Miami decides which galleries are eligible to exhibit at the fair, but it does not necessarily represent their particular

64

taste in design. The one exception to this is the Designers of the Future Award, which reflects the opinion of the committee regarding which designers are worth watching for in the future. Classic product designers such as Peter Marigold and Raw-Edges had won the previous year's award. The year Beta Tank won, none of the winners were working conventionally as product designers: Zigelbaum + Coelho, from MIT Media Lab, experiment with electronics, user interfaces, tangible computing, and human interaction; artist Graham Hudson was resident artist at the time for the King's Cross redevelopment program in London; Random International work with light mechanisms and electronic curiosities.

DESIGNERS OF THE FUTURE AWARD

TAXING ART

DESIGNERS OF THE FUTURE AWARD

Fig.1

TAXING ART

Fig.2

Fig.1/2 Borrowing a technique used in fashion production, Raw-Edges folds and refolds DuPont™ Tyvek® to create a series of plush seats. The method of pleating allows the flat, nonelastic material to become a springy, three-dimensional cushion when filled with soft polyurethane foam.

DESIGNERS OF THE FUTURE AWARD

It was great to be in such company and it is a testament to Ambra Medda, Wava Carpenter, and Alexandra Cunningham, who found all of us from different corners of the world and saw the potential in this collection of misfits. Their approach helps broaden the definition of what design can be. The reputation of Design Miami brought W Hotels on board to sponsor the award. Together they created an eclectic show that took risks on a world stage.

Fig.1 TARTRAT, Peter Marigold

TAXING ART

Fig. 1

The Taxing Art

TAXING ART

Tour

Transportation

Transport is a major part of my business because I live in Berlin but all of my work happens outside of Germany. When I transport inside the EU, VAT is the same as it is locally and there are no import duties. There is, however, one very interesting phenomena that creeps in even when transporting in the EU: though prices are reasonable even for heavy crates, the moment the transport company thinks you are transporting art you are immediately transferred to a different department and charged a higher fee.

I used the German logistics company DB Schenker for the *Taxing*

TAXING ART

TRANSPORTATION

Art world tour because they can handle any type of delivery to any part of the world as long as it starts or ends in Germany. Using one company for the project was important to me; I wanted to get to know the people in the company and understand its structure. This had particular value because just as I collect VAT on behalf of the government, freight companies have to correctly classify goods on behalf of the tax authorities. This meant that it was the employees at the logistics company who would need to be convinced whether an object was a piece of art, furniture, or regular commercial goods.

Fig. 1 My only documentation from the trip to Basel were these police camera images and a 30 € fine.

TAXING ART

Beweisfotos zum Sachverhalt, Aktenzeichen TH9914-181785-10/1

Fig. 1

Avoiding Switzerland, an Interview with Max Lamb

Exhibition: Commissioned
Gallery: Johnson Trading Gallery
Place: Milan 2010

BT

Why did you decide to drive to Milan form the U.K.?

ML

The reason was 90% economical and 10% for the sheer thrill of driving. I had a whole van's worth of stuff to take, which to send by courier or shipping agent would have been far more expensive. Plus it gave me more time to finish making my furniture so I could work right up to the last minute. With a courier I would have had to send it three days earlier to arrive on time. Sometimes (mostly, in fact) it is just more efficient to do these things yourself. Very much the same way that I like to be independent in the production of my furniture.

BT

Did you prepare for a customs check upon leaving the U.K.?

ML

There were no papers. Even if they asked to see papers, I wouldn't have had any papers. I don't know what I would have had to do. They were actually very friendly. There were a lot of boxes in [the van] and some pieces of furniture they could quite clearly see. They just asked what I was doing and I was just totally honest with them. I just said I was doing a furniture fair in Milan and exhibiting all the pieces. That they are mostly prototypes and one-off pieces. I think I didn't tell them that they are for sale—I just said they were for exhibition purposes and they will all be coming back into the country.

BT

How did you plan the route?

ML

The most direct route from London to Milan—and the one suggested by both AA and Michelin online route-finders—takes you straight through Switzerland, entering through Basel. Having a Swiss co-driver and navigator should have helped us charm our way through Swiss customs, but he was of the opinion that we should bypass Switzerland completely. Apparently the Swiss customs are especially strict with commercial vehicles and will without a doubt ask to see full paperwork of the contents of the van and demand payment of the import tax based on the value of all the goods on board and in theory the import tax is reimbursed as you drive out of Switzerland at the other end. This procedure could take up to a day, if not more, and I had set myself the challenge of driving the 754 miles (plus ferry crossing) in a day, so we decided to circumnavigate Switzerland in France and drive into Italy through Mont Blanc. The new route was 847 miles, taking us a further 93 miles, plus it introduced us to the expensive —and notorious for congestion—Mont Blanc crossing. But it was still a more attractive option than dealing with Swiss customs.

TAXING ART

Fig.1 *Undefined*, Max Lamb

Fig.1

AVOIDING SWITZERLAND

Fig.1

TAXING ART

Fig.2

Fig.1 Commissioned exhibition, Milan 2010.
Fig.2 Mont Blanc region on the way to Milan from the U.K.

BERLIN TO BASEL

Berlin

TAXING ART

Basel

Berlin to Basel

It was only later that I learned the real reason designers avoid Switzerland: the country's mafia-like approach to duties collection. Upon entering Switzerland, all taxes must be paid upfront. It does not matter if you are only driving through with no intention to stay. If you sell your goods, no further action will be needed and if nothing is sold, they will refund your money.

A rented van with German license plates was sure to get stopped at the border. How much more obvious could it be that something was being transported into the country? After ten hours of driving, as my partner and I approached the Swiss border, I had a measure of trepidation and had to remind myself that I wanted to get stopped. Despite our hours on the road, I was still up for a debate on the art or design question, but when my turn came the official waved us through. All that effort and then nothing, which was very disappointing—until I realized that Art Basel has a tax office inside the fair. We had unintentionally created an even bigger issue because we were now officially smuggling goods into the country–and during the world's most important art and design fair the Swiss government has customs officials go from booth to booth inspecting the tax declaration papers.

The vernissage came and went and so did the first and second days. I forgot about the customs swat team and entered design fair mode, which enables me to explain the same thing over and over for ten hours straight. Design fairs attract an eclectic crowd ranging from super geeks to people interested in DIY to art and design collectors. There is no way to identify who would be good to chat with, so I just speak to as many people as possible. So when three ordinary-looking people entered my booth, I approached them and started to chat. The government tags they wore around their necks completely escaped me and then they responded in Swiss German, asking me if they could see my papers. My heart sank. I panicked. I felt like a wanted fugitive. I replied that I had no papers to which one of the officials replied, "That is very bad."

I don't speak German and was trying to flag Michele down for some linguistic assistance but she was in the middle of being interviewed by Julian Ellerby from the Future Laboratory. I was convinced that I would be arrested—a very embarrassing prospect in the midst of a prestigious design fair—but reminded myself that this is exactly what I had wanted and the worst that could happen was that I would pay a fine. I grabbed Michele mid-interview and asked Julian to be our photographer if Michele and I were indeed going to be taken to jail.

Instead of going to jail, I got to have the conversation I wanted with the customs officers. They asked to see the exhibition price list (which I had made up the day before with inflated prices) and I realized that I was about to pay 7.6% VAT on the entire amount as well as a hefty fine. But instead giving us a fine, they wanted to know who the artist was and upon telling them it was both of us, they declared that there would be no duties to pay; they had decided that the work was art.

A bit stunned and relieved that I wouldn't have to pay the higher rate of VAT, I asked how they had come to their decision. The answer? They had entered the fair through the door with the sign that read "Art Basel" and that artists traveling with their own work do not need to pay duties.

TAXING ART

Fig. 1

Fig.1/2 For the set design of Design Miami/Basel we hired the help of Catherine Anyango, a London-based illustrator. Catherine designed a room of mirrors, which allowed the objects to be viewed in many different angles. This option played with the notion that objects are treated differently in different contexts.

Fig. 2

BERLIN TO BASEL

Fig.1

TAXING ART

Fig.1 *Taxing Art* installation in Basel. The front section is a replica of a 1960 tax office with the *Taxing Art* objects in the back room awaiting classification. Design Miami/Basel 2010.

BERLIN TO BASEL

Fig. 1

Fig. 2

Fig. 3

88

TAXING ART

Fig. 4

Fig. 5

Fig. 1-5 In the end we decided that as the objects already discussed a complex issue, the props and set design should be simple and help introduce viewers to the issue.

BERLIN TO BASEL

A bit stunned and relieved that I wouldn't have to pay the higher rate of VAT, I asked how they had come to their decision. The answer? They had entered the fair through the door with the sign that read "Art Basel" and that artists traveling with their own work do not need to pay duties.

Fig. 1

Fig. 2

TAXING ART

Fig.1-4 Images from the *Taxing Art* installation at Design Miami/Basel 2010.

BERLIN TO BASEL

Fig. 1

Fig. 2

TAXING ART

Fig. 1-4 These are the Swiss customs officials who came to check our customs declaration in Basel. The stamp was given to us once the officials were satisfied that we were indeed the artists.

BERLIN TO BASEL

Fig.1 *T228/89* table by Beta Tank in the *Taxing Art* installation space Design Miami/Basel 2010.

Photography: jamesharris.co.uk

TAXING ART

BERLIN TO BASEL

Fig.1

TAXING ART

Fig.1 *Chanimal No.1* by Beta Tank in the *Taxing Art* installation space Design Miami/Basel 2010.

Photography: jamesharris.co.uk

Fig.2 *Box Of Loose Hammers* by Beta Tank in the *Taxing Art* installation space Design Miami/Basel 2010.

Photography: jamesharris.co.uk

W HOTEL DESIGNER TOUR

98

TAXING ART

W Hotels Designer Tour

The Designers Of The Future Award was sponsored by W Hotels. I knew about the brand but had never stayed at any of their hotels. During the Milan Furniture Fair and again at Design Miami/Basel, I found the W global brand team, which was headed by Eva Ziegler, to be genuinely interested in the design process and open to working with the award winners on a long-term basis.

This support lead me to propose a touring exhibition at W Hotels around the world. W was the perfect sponsor for me; they had locations in countries I wanted to explore, a different audience, and they could help me with the logistics of the project. I spoke to W's Rebecca Rand and George Fleck and they were very supportive and enthusiastic about the proposal. Together we hashed out a tour of three different locations on three continents with very different cultures and tax regulations. I would have a very tight schedule, going from Berlin to Barcelona to Istanbul to Doha and then back home to Berlin.

When Art Basel was over I began to prepare for the tour. The traveling exhibition had to function independently of me so that once it arrived in a location anyone at the hotel could set it up and take it down. Most importantly it had to tempt customs officials to inspect the goods. I knew that this would probably not happen in Spain because it would be a shipment within Europe, but after Barcelona the goods would move to Istanbul. Transportation is like a large puzzle and every piece has to fit together. If the invoices are not identical with the same goods on each invoice, customs will assume that you are in the import and export business. Unaware of the consequences of what I was getting myself into, I decided to do things the hard way and have different names for the objects each time I transported the goods. This was the only way I could ensure that the customs officials would look at and classify the goods.

Because this was my first tour, I thought that one large crate would make the most sense; the objects wouldn't get lost in transit, I'd have large surfaces on which to write messages to customs officials, and the freight companies would have lots of space for their labels. The crate ended up being a mini project of its own. Most crates are screwed together, but I wanted to make it easy to open for anyone tempted to inspect it along the way. The Berlin-based carpenter Jan Ohl and I worked together to make a super crate. The entire exhibition was housed snuggly and neatly inside of it. Black felt carpeted the interior, all of the crate's pieces were identical (making it easy for anyone to reassemble after opening), and the crate had latches instead of screws. The latches were the most important detail because anyone could easily open the crate. With the crate ready and the objects inside, I prepared the transport to W Barcelona.

In 1988, the first W Hotel opened in New York.

At the beginning of 2011, 41 W Hotels exist around the world.

BERLIN TO BARCELONA

Berlin

TAXING ART

Barcleona

BERLIN TO BARCELONA

DB SCHENKER

SCHENKER Deutschland AG - Postfach 130209 - 13601 Berlin

Herr
Eyal
Burstein
Ritterstr. 12-14
10969 Berlin

Kontakt: Frau Christina Homburg

Schenker Deutschland AG
Jafféstr. 2
14055 Berlin
Telefon: 030/3012995-471
Telefax: 030/301 2995 -479
Email: Christina.Homburg@dbschenker.com

Original

Rechnung: 1034323077

Angebot-Nr.:	1201008042	Firmen-Steuernr.:	045/2312/8552	SWIFT-NR.:	DRESDE FF 100
Auftrag-Nr.:	08892534810	Firmen-USTID.:	DE 811228366	IBAN-Nr.:	DE44100800000410435300
Kunden-Nr.:	190504	Kunden-USTID.:		Datum:	20.08.2010

Umzug von: 10969 Berlin, Ritterstr. 12-14
nach 08039 E-Barcelona Placa de la rosa del vents 1 für: Herr Eyal Burstein

Datum	Anzahl	Text	Stck/Std.	Preis	Mwst	Marge	Kurs	Summe	Wah.
		Transport Berlin - Barcelona 3 packed paletts	1,00	235,29 EUR	19,00			235,29	EUR
		Gesamtnettobetrag						235,29	EUR
		235,29 EUR Nettosumme mit 19,00% Mwst.						44,71	EUR
		Gesamtbetrag						**280,00**	**EUR**

Zahlungsbedingungen : payment prior to transport

Schenker Deutschland AG
Umzugsabteilung
Servicegebäude Süd / Einfahrt Tor 25
Jafféstr. 2
14055 Berlin
Telefon +49 (0) 30/ 301 2995 -470
Telefax +49 (0) 30/301 2995 -479
E-Mail: umzug.berlin@dbschenker.com
www.dbschenker.com/de

Sitz der Gesellschaft ist Frankfurt/M.
Amtsgericht Frankfurt am Main
HRB 51435

Bankverbindungen:
Dresdner Bank, Berlin
(100 800 00) Kto. 4 104 353 00

Vorsitzender des Aufsichtsrats:
Karl Nutzinger
Vorstand: Dr. Hansjörg Rodi (Vors.),
Michael Korn (Stellv. Vors.)
Dr. Michael A. Kluger, Lothar Rosenbaum
Frithjof Schäfer, Aloys Winn

```
This is the receipt for transport from
Berlin to Barcelona. The first of many.
```

TAXING ART

Berlin to Barcelona

Sending the crate from Berlin to Barcelona was a straightforward EU delivery. There was no need for a goods invoice or a customs declaration. The exhibition was on display for a month in the lobby of the flagship W Barcelona. I was invited to be on-site for two days, giving me one day for media interviews and another to pack the crate and see it off to Istanbul.

There were ten days until the start of the Istanbul Design Week, by which time the crate had to get to Turkey, be cleared by customs, and still leave me enough time to set up the exhibition. I assumed that the hotel would send the work as art—or at the very least as articles for exhibition purposes. The moving company informed me that Turkish customs were very strict and that for the sake of time, our best bet would be to classify them as "wooden furniture." This was a strange suggestion because of all the materials in the crate, wood was the least used. Nevertheless, I classified the crate as containing wooden furniture and waited to see how Turkish customs would deal with the fact that the objects were not made of wood or that only half of the contents could be used as furniture. I was very interested to see what would happen because there has never been a case in which customs has overturned a wrongful classification from commercial goods to works of art.

BERLIN TO BARCELONA

TAXING ART

Fig.1-20 The shock on the face of the single removal man who was sent to pick up the crate was an omen of things to come. Several design flaws in the crate meant that getting the now 300 kg crate out of my studio took four people.

BERLIN TO BARCELONA

Fig.1

TAXING ART

Fig.1-3 The super crate housed the entire installation, with each objects housed in its own carpeted section.

BERLIN TO BARCELONA

Fig.1/3 The impressive W Barcelona, visible from everywhere in the city.
Fig.2 *Taxing Art* exhibition space in W Barcelona.
Fig.4 The crate loaded in Barcelona on its way to Istanbul.

108

TAXING ART

Fig.4

On the last day, I had a mere four hours to take down
the show and pack everything into the crate, which was
somewhere deep in the cellar of the enormous hotel.

BACK IN BERLIN

TAXING ART

BACK IN BERLIN

Fig.1

Back in Berlin

Fig.1/2 It took two people and almost 16 hours to lacquer each tile.

Istanbul Design Week ran from September 29 to October 2, 2010. I returned to Berlin on the evening of the 17th and still had to send to Istanbul the remainder of the *Taxing Art* installation as it was shown during Art Basel. This included a 1950s/1960s tax office equipped with old desk, typewriter, counting machine, and a tiled pyramid floor of approximately 30 square meters. I used 250 plywood squares and laser-etched them with a pyramid pattern. The tax office desk was made from MDF plates that clicked together to make a desk. I packed the whole installation on a standard Europallet and sent my goods invoice to the moving company.

From my experience in Barcelona, I knew I had to convince the moving company that the transport was art. I couldn't just tell them to enter the classification

I wanted; I had to make them feel confident about the classification so that it would clear customs quickly. My goods invoice described the plywood squares as etched wooden tiles and the desk as an MDF sculpture. It didn't take long for the moving company to email me asking for clarification. They wanted me to describe exactly what materials made up these goods.

So here it was again: the same exact issue the tax authorities had had with the artist who made the paperweights. Instead of looking at the constructed table, it was classified as its constituent parts. But instead of having a discussion with the tax authorities, I had it with the moving company.

The pallet was classified in two sections: the tiles were sent under the 44219098

TAXING ART

code ("wood marquetry and inlaid wood; caskets and cases for jewelry or cutlery, and similar articles, of wood; statuettes and other ornaments, of wood; wooden articles of furniture not falling in Chapter 94"). The MDF sculpture was not sent as a work of art but as "fiberboard of wood or other ligneous materials, whether or not bonded with resins or other organic substances," sub–section "of a thickness exceeding 9 mm" sub–section "other." Put simply: other bits of MDF exceeding 9 mm. It was great to know that MDF had as many codes as art did. And it was reassuring to notice that if the authorities want to, they can be refined in their classifications and that there is hope that the art codes could be broadened. This would make them more relevant—and keep other manufacturers from using them fraudulently.

With the first stage over I was informed by the movers that the pallet would not arrive on time if delivered by land. DB Schenker was very helpful and the pallet was diverted from their trucking warehouse to the airfreight cargo terminal at Tegel. Moving from land to air brought with it a whole host of new forms to fill in. I was asked by the moving company to apply for an EORI (Economic Registration and Identification) number. This is used by the government to keep track of what you are transporting and is claimed to improve security. I'm not sure what the point of this number is, as it seems only a necessity for deliveries inside the EU. I was then asked to issue a power of attorney to the moving company allowing them to act on my behalf when dealing with customs in Turkey. All this took awhile and now the pallet was due to leave on Sunday, September 26, just three days before the start of Istanbul Design Week. My assistant, John Annett, and I left on the 26th and arrived early Monday morning, September 27.

Fig.1/2 The mobile floor weighed over 100 kg.

Fig.2

BACK IN BERLIN

TAXING ART

BACK IN BERLIN

Fig.1/2 While we were in Basel, a European collector approached me and commissioned a chair that resembled the *T228/89* dining table.

Fig.1

TAXING ART

Fig.2

BARCELONA/BERLIN TO ISTANBUL

Barcelona/Berlin

TAXING ART

Istanbul

EUROPÄISCHE GEMEINSCHAFT

LISTE DER WARENPOSITIONEN - AUSFUHR

Vordrucke (3): 2 / 3

MRN 10DE215225890122E7

Á10DE215225890122E7`È

Pos.-Nr. (32)	Anzahl und Art der Packstücke, Zeichen und Nummern der Packstücke (31.1)	Warenbezeichnung (31.4)	
Versender/Ausführer (2)		Empfänger (8)	
Kennzeichen des Beförderungsmittels beim Abgang (18)		Warennummer (33)	
Kennnummer der Sendung (Unique Consignment Ref. Nr.) (7)		Summarische Anmeldung/Vorpapier (40)	
Vorgelegte Unterlagen / Bescheinigungen (44.1)		Container-Nr. (31.3)	Nummer des Zollverschlusses (S28)
Besondere Vermerke (44.2)		Verfahren (37) / Ausfuhrland (15a) / Bestimmungsl. (17a) / Rohmasse (kg) (35)	
UNDG (44.4)	Beförderungskosten, Code für die Zahlungsweise (S29)	Anmeldungsart (1) / Statistischer Wert (46)	Eigenmasse (kg) (38)

1 1. 1 PX, Palette 255 Stück Mosaikteile aus Holz

BETA TankEyal Burstein
Rosa Luxemburg Straße 23
10178 Berlin
(DE) Deutschland

44219098

ohne

Internationale Unterlagen:
T:N380
R:BT001

Handelsrechnung
T:Y900
R:

Die angemeldeten Waren fallen nicht unter das Washingtoner
Übereinkommen (CITES)
T:Y903
R:

Die angemeldeten Waren sind nicht in der Liste der
Kulturgüter enthalten
T:Y906
R:

Andere Güter, als die in den TR-Fußnoten zu der Maßnahme
708 beschriebenen. (nicht in Anhang III der Anti-Folter-VO
(EG) Nr. 1236/2005 gelistete Güter)

		2300	DE	TR	90
					70

PALLET ARRIVING IN ISTANBUL

T.C. GÜMRÜK BEYANNAMESİ	Seri : VK 0823098		1 BEYAN	A VARIŞ GÜMRÜK İDARESİ A.H.L. KARGO GÜMRÜK MÜDÜRLÜĞÜ	
2 Gönderen / İhracatçı No --- BETA TANE EYAL BURSTIN ROSA LUXEMBURG STR 23 10178, BERLIN GERMANY 004			EU 4	103403001M342439 28/09/2010	
		3 Formül 1 2	4 YÜK. listeleri 4		
		5 Kalem sayısı 4	6 Kap adedi 1	7 Referans numarası kz1000000127	
8 Alıcı No 0130591977 AKARETLER OTEL İŞLETMECİLİĞİ VE TURİZM ANONİM VİŞNEZADE MH SÜLEYMAN SEBA CD NO 7/ İSTANBUL/BEŞİKTAŞ 052			9 Mali Müşavir/Serbest Muhasebeci No 0130591977 AKARETLER OTEL İŞLETMECİLİĞİ VE TURİZM ANONİM VİŞNEZADE MH SÜLEYMAN SEBA CD NO 7/ İSTANBUL/BEŞİKTAŞ 052		
			10 Sevk ülkesi 004	11 Ticaret yapılan 004 ülke	
14 Beyan sahibi / Temsilcisi No 7330425983 ROYAL GÜMRÜK MÜŞAVİRLİĞİ LİMİTED ŞİRKETİ İÇERENKÖY M.KAYIŞDAĞ IYOLU HAKKIEKŞI HAN NO İSTANBUL/KADIKÖY 052			15 Çıkış/ihracat ülkesi ALMANYA		
18 Çıkışlık taşıt aracının kimliği ve kayıtlı olduğu ülke UÇAK UÇAK/ALH8300		052	19 Ktr 0	20 Teslim şekli DDU İSTANBUL	
21 Sınırı geçen hareketli taşıt aracının kimliği ve kayıtlı olduğu ülke UÇAK UÇAK/ALH8300		052	22 Döviz ve toplam fatura bedeli EUR 1,000.00	23 Döviz kuru 1.98736 24 İşlem 1	1
25 Sınırdaki taşıma 10	26 Dahili taşıma şekli	27 Boşaltma yeri AHL	28 Finansal ve bankacılık verileri ARACI BANKASI YOK		
		30 Eşyanın bulunduğu yer A.H.L. KARGO GÜMRÜK MÜDSİSTEM ANTREPO	BEDELSİZ		
31 Kaplar ve eşyanın tanımı Markası: ADER Numarası: Tarifi Genel Ticari Ünvanı: ahşap kuro "bedelsizdir" kullanımdır Orijinal Faktura V BT 06115.00.2010 015-09-10 ATR Dolaşım Belgesi V D 01901522.09.2010 922-05-10 İthal evrakının alı Kıymet Bildirim Formu V EKI 028-09-10 TC BEŞİKTAŞ 2.NOTERLİĞİ 018012R.01.2009 "KONŞİMENTO-020-69020066"BEDELSİZDİR"			32 Kalem 1 No	33 Eşya kodu 44219098 90 00	
			34 Menşe ülke kodu 004	35 Brüt ağırlık (kg) 70.00 36 Tercihli tarife AT	
			37 REJİM 40 00	38 Net ağırlık (kg) 70.00 39 Kota	
			40 Özet beyan 103403001M119360-27/09		
			41 Tamamlayıcı birim 255 ADET(UNIT)	42 Kalem fiyatı 400.00 43 HY Kodu	
			E.B. Kodu	45 Ayarlama	
				46 İstatistiki kıymet 538.67	
47 Vergilerin H Tür Vergi matrahı Oran Tutar ÖŞ 10 0 0.00 P 40 18 161.19 P 80 37.25 P Toplam: 201.44				48 Ödemenin ertelenmesi 49 Antreponun tipi ve kodu	
			B HE FATURA NAVLUN SİGORTA CIF YDIŞI GVM GV YICI	1,987.30 0.00 0.00 1,987.30 0.00 1,987.30 0.00 200.00	
50 Asıl sorumlu No		İmza		C HAREKET GÜMRÜK İDARESİ	
51 Gümrük şubesi	Teminatı Yer ve tarih:				
M İzmal sorumlu			Kod 53 Varış gümrük idaresi ve ülkesi		
I VARIŞ GÜMRÜK İDARESİ KONTROLÜ		Müdür 9A 31.63	54 Yer ve tarih İSTANBUL 23.09.2010 Beyan sahibi / temsilcinin imza ve adı: RESUL ŞAHİN M 34/1218		

Dossier: E 10858

COMUNIDAD EUROPEA

A ADUANA DE EXPEDICIÓN / EXPORTACIÓN

1 DECLARACIÓN: EX A 10ES0008011 185055 5

2 Expedidor/Exportador Nº ESB65193443
WISSE MOVING
C/ AMADEU, 160
08370 CALELLA
BARCELONA
ESPAÑA

3 Formularios: 1 **4 List. de carga**
5 Partidas: 1 **6 Total bultos:** 1 **7 Número de referencia**

8 Destinatario Nº
HOTEL W ISTANBUL
SULEYMAN SEBA CAD. Nº 22 AKARETLER
34357 ISTANBUL
TURQUIA

9 Responsable financiero Nº

14 Declarante/Representante Nº ESA08672065
[3] JAS FORWARDING SPAIN, S.A.
"O"

15 País de expedición / exportación: ES
16 Cód. P. exped./export: ES
17 Cód. país de destino: TR
16 País de origen
17 País de destino

18 Identidad y nacionalidad medio transporte a la partida
19 Ctr.: 0
20 Condiciones de entrega: DDU ISTANBUL

21 Identidad y nacionalidad medio transporte activo en frontera
AVION TURKISH AIRLINES TR
22 Divisa e importe total factura: EUR 40000,00
23 Tipo cambio: 1,000000
24 Naturaleza: 1 1

25 Modo transporte en frontera: 4
26 Modo transporte interior
27 Lugar carga
28 Datos financieros y bancarios

29 Aduana de salida: ES000801
30 Localización de las mercancías: 0801 08A029

Bultos y descripción de las mercancías
RTDAS 1 BX
MUEBLES DE MADERA.

32 Partida Nº: 3
33 Código de las mercancías: 94036090 4099
34 Cód. país de origen: ES 08
35 Masa bruta (kg): 458
37 RÉGIMEN: 10.00
38 Masa neta (kg): 350
40 Documento de carga/Documento precedente

41 Unidades suplementarias: 40.000

Indicaciones especiales/Documentos presentados/Certificados y autorizaciones
1005 ES. 17-9-10
N380 ES S/N 17-9-10
N740 235-61395784 17-9-10
N018 ES GA0055935CD 17-9-10

Cód. I.E.
46 Valor estadístico: 38.4

Cálculo de los tributos | Clase | Base imponible | Tipo | Importe | MP
48 Aplazamiento de pago
49 Identificación depósito
B DATOS CONTABLES

Total
50 Obligado principal Nº Firma
C ADUANA DE PARTIDA

Aduanas de paso previstas (y país)
representado por
Lugar y fecha

Garantía no válida para
Cód. **53 Aduana de destino (y país)**

CONTROL POR LA ADUANA DE PARTIDA
Admitido: 17-9-2010 Autentic: 4A42856DD8046778
Resultado: Levante: 17-9-2010 Cto. Verde
Precintos colocados: Número:
marcas
Plazo (fecha límite):
Firma

54 Lugar y fecha: BARCELONA 17-9-2010
Firma y nombre del declarante/representante
JAS FORWARDING
XAVIER PEREZ
46226689R

AUTENTICACION INFORMATICA, ART. 199.2 R. CEE 2454/9

CRATE ARRIVING IN ISTANBUL

It is interesting to note that the HS code had changed a little bit
between Barcelona and Istanbul. In Barcelona it was 94036090, in
Istanbul it became 94036010. This is only a small regional difference,
but one that meant full import duties were liable.

123

BERLIN TO ISTANBUL

Fig.1

124

TAXING ART

Fig.2

Berlin to Istanbul

My contacts in W Istanbul, who know how complicated Turkish customs are, quickly spoke to a local customs agent. (I found out later that because W Istanbul has had so many issues with customs, they no longer import anything major and locally produce almost everything they need—I suppose this was intention of customs in the first place).

Fig.7 Later that day the pallet arrived in an even smaller van. Once again the team at W Istanbul came to the rescue.

My own process was getting quickly complicated and I was eager to find out what the customs officials would make of my crate, which obviously wasn't full of wooden furniture. Our customs agent informed me that he had found the crate and pallet and was starting the customs clearance process. It was now our customs agent who would preempt the officials and I bitterly considered the fact that I might never actually get the chance to question the officials; there would always be a business entity separating me from them.

Unfortunately, it really wasn't the right time to have a philosophical conversation with the customs agent. It was the morning of the 28th and I was strictly told that in order to have the objects in the exhibition space that day—which was crucial—I should just let the agent do his work.

I was nervous about the time pressure and had half accepted that instead of the "Taxing Art" exhibition, there would be a sign in the space that read "Taxing Art, stuck in customs." However, this option was not popular with my hosts, so the W Istanbul team made sure that the crate arrived on time.

Suddenly the crate arrived. On a narrow street, where traffic was lawless at the best of times, I spotted my crate on a small mini van that was not much bigger than the crate itself. There was no lifting equipment and no papers to sign, just a massive crate bearing battle scars from its journey. The crate was battered; it looked like customs had inspected it with an axe.

After things had settled down and both deliveries were installed in the exhibition space, I had time to investigate what had happened at customs. I found

125

BARCELONA TO ISTANBUL

Fig.3

Fig.4

Fig.5

Fig.6

TAXING ART

Fig.7

out that the customs agent was the first person to examine my pieces and had decided that what he was inspecting were parts of furniture found in the dining room. That meant that the Spanish declaration of temporary import was not valid under Turkish regulations. Although the goods were cleared in 24 hours, they had to be imported normally as parts of wooden furniture for dining room purposes. For some reason, this specific classification is free of import duties but an 18% VAT (which would have been suspended if the goods could have been categorized as a temporary import) had to be paid. My objects were now legally owned by W Hotels Istanbul and not by me.

I was grateful for all the help I received from W Istanbul, especially the logistical and financial assistance. The whole procedure showed me how difficult it is to move around with unique, one-off objects. If art is a practice that most of the world agrees is worth supporting, there should be a way of making it more easily accessible to markets. Manufactured goods have these costs included in their price; in fact, the goods are only made if these costs allow for an object to be sold. Art is different because it is not made with that consideration. Each time it is treated as commercial goods, its price is raised beyond what most people are willing to spend.

When Istanbul Design Week was over, I packed the entire exhibition into the crate with a few modifications; I replaced the mangled latches and raised it off the ground so that a fork life could fit underneath and maneuver it more easily.

Because the goods came into Turkey as a normal import, W Istanbul had to export the goods to W Doha. Dealing with this particular part of life, which I would normally try to avoid, was taking its toll. I had still not managed to classify *Taxing Art* exhibition as art, although I had gotten to go deep into the inner workings of the companies that surround the customs process. I was extremely anxious about the next leg of the tour. Qatar has no income tax or VAT and its import duty is 4% on almost all goods. Would customs even react to any of this? Would the locals in Doha engage with me in discussion surrounding *Taxing Art*?

Fig.1/2 The heavy crate had to be dismantled on the van and each piece carried into the exhibition space. The entire management team of W Istanbul came to help, which was very heartwarming.

BARCELONA TO ISTANBUL

TAXING ART

BARCELONA TO ISTANBUL

Fig.1

TAXING ART

Fig.1 *Chanimals* side by side.
Fig.2 During the set-up the crate became our desk and later storage space.
Fig.3 "Taxing Art" exhibition in Istanbul.
Fig.4 Tax office MDF desk with 1960's accessories.

131

ISTANBUL TO DOHA

Istanbul

TAXING ART

Doha

CRATE LEAVING ISTANBUL

The crate, which by now included the entire exhibition, was cleared by Turkish customs as 94036010: "wooden furniture of a kind used in the dining room and the living room."

CRATE ARRIVING IN DOHA

When the crate arrived in Doha, it was classified as 94034020. "This code does not actually exist, but it is part of the 4940340 section and is defined as wooden furniture of a kind used in the kitchen."

ISTANBUL TO DOHA

Fig.1

TAXING ART

Fig.1 View of Doha from my hotel room window.
Fig.2 View of Doha from the hotel entrance.
Fig.3 Even though there are bar codes and tracking numbers for each delivery these are not supplied willingly and must be requested.

137

ISTANBUL TO DOHA

Fig.1

Doha

I arrived late at night in Doha on October 24, 2010. The 800 kg crate had arrived a week before me and I was afraid it might have cracked open en-route. The next morning I was shown the crate, which stood unprotected outside the goods entrance. Part of the underside had been ripped out and the latches were in worse shape than they had been in Istanbul. I immediately asked if there was a chance that someone could have touched the crate during the week it was outside but I was simply told that there is no stealing in Qatar.

The hotel's general manager, Safak Guvenc, encouraged me to place the table in the center of the lobby. I was very happy that the hotel management felt that these objects would complement their interior and that every person who passed through would see my work. The hotel was fully booked due to both the Tribeca Film Festival and the WTA Championships, which were happening simultaneously. Setting up an exhibition in a busy place is always a challenge. I got the crate to the front entrance and started taking apart the battered sections, clearly decreasing the hotel's atmosphere, as stretch limo after stretch-limo stopped to unload passengers in front of the striking hotel entrance.

As with all previous deliveries, I did not have access to any of the officials and none of the conversations about classifications happened in real time. I spent some time in the hotel room piecing together the customs puzzle. The crate,

TAXING ART

which by now was a combination of both pallet and crate, and at one point had had three very separate codes, had left Istanbul as HS code 94036010 but had entered Doha as 94034020. The last two codes are from Chapter 94, which deals with different types of wooden furniture. Since Barcelona, the crate had shifted from one subcategory in that chapter to another. Because the crate and its contents were officially owned by W Istanbul, the crate had to be imported officially into Doha which incurred a 4% import duty, which was about 340 €.

After three days in Doha, it was time to return for the last time to Berlin. I had lost hope of ever classifying the *Taxing Art* objects as art and had left without instructions as to how the crate should enter Germany. It was very clear by now that the companies involved in supplying services that surround deliveries try and make their own—and in turn their customers' lives—as simple as possible. They do this be understanding as to what their country's customs authorities find reasonable as to what to let in or out of the country. When I received the customs declaration, I noticed that the crate had left Qatar as personal effects, which is a category that Qatar does not levy any duties or VAT on when leaving the country.

Fig.1 This was how I found the crate on arrival to Doha.
Fig.2/4 The crate infront of the hotel entrance.
Fig.3 Hotel luggage trolleys used to carry the *Chanimals*.
Fig.5 Staff and artist Graham Hudson helping to carry the *T228/89* table in to the hotel.

ISTANBUL TO DOHA

Fig.1

TAXING ART

Fig.1 This day trip to the desserts just outside Doha was a welcomed reminder of where we really were.
Fig.2/3 Pictures from the exhibition.

DOHA

Fig.1

TAXING ART

Fig.1 Picture from the exhibition.
Fig.2-5 On my last day in Doha I patched up the crate with Graham Hudson, who did most of the repairs. I had to use some of the plywood tiles I used in the exhibition to mend the section under the crate that was torn off.

143

Doha

TAXING ART

Berlin

BERLIN

Fig.1

Back in Berlin Again

On Thursday, December 9, 2010 I received a call from Swissport Cargo Services at Tegel International Airport in Berlin; my delivery had arrived. Usually deliveries are made door to door, but mine was stuck in customs. I had foolishly thought that Doha would be the last time I would deal with the whole import/export world, but as if in a twist of fate, I got one last chance to classify my work as art.

I contacted my trusted moving company, DB Schenker, and started the process I knew all too well. This time there was no time pressure and I was adamant about ensuring that the *Taxing Art* objects came into Germany as works of art.

I found myself negotiating with the moving company about the artistic merits of my objects. I prepared a strong case and issued a new goods invoice with five separate positions, one for the ply-wood floor, one for the MDF desk and a yellow pyramid sculpture for the table, an abstract sculpture for the *Chanimals*, and a geometric acrylic shape for the *Box Of Loose Hammers*. Along with the new goods invoice, I sent images of all of these objects in an art context. It took a week of negotiations with the moving company to agree to even try to ask customs to let the goods in as works of art under HS code 9703 and in the end they only agreed to do this if the objects were classified separately form the tiles and desk. On the same day the moving company cleared the crate through customs, I received word from the moving company that customs had agreed to let the crate in to Germany. The plywood tiles and MDF desk under the code 44219098 (other, ironing boards, including sleeve boards, whether or not free standing, and legs and tops thereof) and the *Taxing Art* objects as works of art under the 9703 code.

146

TAXING ART

Fig.2

Fig.3

Fig.1-3 Back in Berlin the crate was broken in a few places. The *Box of Loose Hammers* had cracked and the *T228/89* table needed a complete new coat of paint.

147

BERLIN

TAXING ART

CRATE FROM DOHA

The crate was exported from Qatar to Germany as personal effects in order to bypass any duties. The code for this is 98010.

150

CRATE IN BERLIN

```
Beschauanordnung          Keine Beschau
Mitteilung an Beteiligten (Beschau):

Zollbefund / Vermerke

Ursprungsl  DE GERMANY, FEDERAL    Bruttogew           Nettogew         598.3
Packstuecke     1 Packung/Packstu      AHSTAT Menge/Masseinheit
Warennummer  9703 0000 00 0/      /
Warenbeschr  ORIGINALERZEUGNISSE DER BILDHAUERKUNST
             (SKULPTUR "GELBE PYRAMIDEN", 3 ABSTRAKTE SKULPTUREN UND
             1 GEOMETRISCHE ACRYL SKULPTUR)
Artikelpreis     4000.00
Zusaetze

Verfahren    4010
EU-Code
Zollwert        4569.91 zum EUST-Wert geh. Kosten      755.46
Stat. Wert      4569
Departure    DOH/DOHA
                   Betrag in FW    WRG    Kurs      Betrag in EUR    %
Nettopreis         4000.00 EUR                      4000.00
Mittelb. Zahlung
Hinzurechng/Abz.
B17A - Befoerderungs    6659.32 QAR 5.0245          1325.37 EUR 043

Art der Unterlage              Nummer              Datum

Hauptzollamt Potsdam Zollamt Berlin-Flughafen Tege Seite   5   zur
Flughafen Tegel                                    Zollanmeldung v. 28.12.2010
13405 Berlin                                       Sendungsnr 6212000401/ 1 EZ
------------------------------------------------------------------------------
Registriernummer 2105/ATC40/2010 12/002253 Arbeitsnr
Registrierdatum  28.12.2010
Bezugsnummer     ZOLL  621200040101EZA04           Position:    1
------------------------------------------------------------------------------

Praeferenzcode BEANTRAGT 100     GEWAEHRT 100

                        angemeldete Werte
Warennummer             97030000000
Ursprungsland           DE
Zollwert/Entgelt           4569.91
Kosten fuer EuSt            755.46
Zollmenge
Agrarzollmenge
Bes.Wertangabe
Gehaltsangaben
Verbrauchst.angaben
Kurs Nettopreis
Kurs mittelb. Zahlungen
Angaben D.V.1
                        B17A    5.024500000

Hauptzollamt Potsdam Zollamt Berlin-Flughafen Tege Seite   6   zur
Flughafen Tegel                                    Zollanmeldung v. 28.12.2010
13405 Berlin                                       Sendungsnr 6212000401/ 1 EZ
------------------------------------------------------------------------------
Registriernummer 2105/ATC40/2010 12/002253 Arbeitsnr
Registrierdatum  28.12.2010
Bezugsnummer     ZOLL  621200040101EZA04           Position:    2
------------------------------------------------------------------------------
Position angenommen    JA

Datum der Annahme am    28.12.2010
Ware ueberlassen am     28.12.2010 um 13:17
```

After some intense negotiations with the moving company,
customs declared the crate as containing works of art under
Chapter 97 with the HS code of 9703.

Conclusion

My journey had come to an end. The crate first left Berlin on June 11, 2010 and returned on December 28, 2010. The objects traveled over 12.000 km at a cost of about 8,500 € all in order to find out how taxation effects my design process and what happens when these objects travel around the world.

I discovered that even with all of the existing treaties and conventions, it is not officials who uphold these laws, but regular people who have no real qualifications apart from their experience and assumptions about art. It is the perceptions of these people that count the most. The pyramid table, which is made of steel and wooden pyramids, is

CONCLUSION

a clear example. In Barcelona it was labeled a wooden table; in Istanbul it had been transformed into parts of a wooden dining table; and in Doha the exact same table had become personal effects. Only in Berlin did it finally become a sculpture.

Tax and customs authorities are an indirect reflection of society; the bookkeeper, the accountant, the guy in the moving company, and the customs agent decide how things are classified—authorities only get involved when there is an obvious problem. At the beginning of this journey I believed that the main issue in the case of Farfalla vs Tax Authority Munich was that the objects were given a commercial title, namely, "paperweights."

CONCLUSION

I am now sure that if they had been named differently, Farfalla would have had no difficulties getting their objects classified as art, just as my designer dining table was classified as a sculpture.

It is worth noting that no matter how advanced a tax system is, it is still greatly flawed because ordinary, untrained people apply its rules. I am not saying that they are unprofessional, but there is no possible way that my bookkeeper is aware of the finer points of art or that the customs agent knows about industrial process in design. I would like to suggest a different approach: to codify the innovative elements in art that extend to commercial entities and extend this to other forms of expression that exhibit these traits.

CONCLUSION

It is easy to see if something is made with commercial intent—something which should also be codified. And from a taxation perspective it is simple to notice if an artistic object made in small quantities has turned into a higher sales volume object. I believe there should be a business category, which acts as a sandbox for companies who do not know exactly what they are going to do, but are very innovative and interested in a wide variety of industries. This sandbox should have parameters of sales volumes or yearly turnover. But until the agreed upon thresholds are reached, those companies should be allowed to experiment in their production methods and business practices. It could open a new world of innovation.

APPENDIX

The Journey Numerical

156

APPENDIX

THE NUMBERS

Distance	Cost
Berlin/Basel	
689km	800€
Basel/Berlin	
689km	280€
Berlin/Barcelona	
1,500km	2,542€
Barcelona/Istanbul	
2,238km	2,137€
Istanbul/Doha	
2,720km	1,500€
Doha/Berlin	
4,393km	1,420€
Berlin/Studio	
20km	
Total	
12,249km	8,679€

APPENDIX

Special Thanks

Michele Gauler
Shirah L. Wagner

W team who were always on hand:
Eva Ziegler
Rebecca Rand
George Fleck
Alwin Put
Tia Graham
Julie Franck
Mahmut Kassas
Andrey Medvedev

And everyone at
W Barcelona,
W Istanbul, and
W Doha.

People who were always there:
Peter Marigold
Wava Carpenter

Alex Cunningham
Tatjana Sprick
Inge Scherre
Jamie Zigelbaum
Marcelo Coelho
Luisella Valtorta
Gianandrea Castellazzi
John Annett
Leah Whitman Salkin
Café Oliv, Berlin
James Harris
Early Bird Hype, Berlin
Jan Ohl
Yalcin Uzuner

Design Miami team who have been so generous:
Kapila Chase
Brittany Savage

Varda Burstein
Haim Burstein
Orly Burstein

APPENDIX

Index

A
Annett, John
p113

B
B-Side
p17, p62, p63

Beta Tank
p7, p8, p12, p17, p24,
p65, p94, p97

Beta Space
p6, p24

Box Of Loose Hammers
p40, p41, p42, p43, p44,
p45, p46, p47, p48, p49,
p50, p51, p97, p146, p147

C
Carpenter, Wava
p70

Chanimals
p28, p29, p30, p31, p32,
p33, p34, p35, p36, p37,
p38, p39, p130, p131,
p139, p146

Cunningham, Alexandra
p70

D
DB Schenker
p74, p146

Design Miami
p7, p24, p42, p43, p64,
p70, p85, p87, p91, p94,
p95, p97, p99

Digital Remains
p21

Dilmos
p17, p62

DMY Berlin
p13

E
Eye Candy
p7

F
Farfalla Flemming
p24, p153, p154

Flavin, Dan
p31

G
Galila Gelb
p116

Gauler, Michele
p12, p21, p33

H
Harris, James
p94, p95, p96, p97

Haunch Of Venison
p31

Hudson, Graham
p65, p139

K
King, James
p21

L
Lamb, Max
p78

Lollipop Tumbler
p24

M
Medda, Ambra
p70

Marigold, Peter
p8, p71

Memory Stücks
p12, p13, p14

Mind Chair MK3
p9

Mind Chair Polyprop
p8

MoMA
p7

P
Barbara Putz
p18

R
Raw-Edges
p65, p69

T
T–228/89 table
p52, p53, p54, p55, p56,
p57, p58, p59, p60, p61,
p62, p63, p86, p88, p89,
p90, p91, p92, p93, p94,
p95, p131, p139, p147

Tax Bench
p38, p39

Taxing Art installation
p87, p91, p94, p97, p112

The Comb
p20

The Flower
p20

U
Uzuner
Edelstahlverarbeitung
p8

V
Viola, Bill
p31

W
W Hotels
p24, p70, p99, p122, p127

Z
Zigelbaum + Coelho
p65

159

APPENDIX

Imprint

Taxing Art: When Objects Travel
Beta Tank
Edited by Shirah L. Wagner
Text by Eyal Burstein

Art direction/design by BUREAU Mario Lombardo
Cover photography by John Annett
Typefaces: Arial, Courier, Times

Project management by
Elisabeth Honerla for Gestalten
Production management by
Janni Milstrey for Gestalten
Copyediting and proofreading
by Rebecca Silus
Printed by SingCheong, Hong Kong
Made in Asia

Published by Gestalten, Berlin 2011
ISBN 978-3-89955-346-8

© Die Gestalten Verlag GmbH & Co. KG, Berlin 2011 All rights reserved. No part of this publication may be reproduced or transmitted in any form or by any means, electronic or mechanical, including photocopy or any storage and retrieval system, without permission in writing from the publisher.

Respect copyrights, encourage creativity!

For more information, please visit www.gestalten.com

Bibliographic information published by the Deutsche Nationalbibliothek. The Deutsche Nationalbibliothek lists this publication in the Deutsche Nationalbibliografie; detailed bibliographic data is available online at http://dnb.d-nb.de.

Gestalten is a climate-neutral company and so are our products. We collaborate with the non-profit carbon offset provider myclimate (www.myclimate.org) to neutralize the company's carbon footprint produced through our worldwide business activities by investing in projects that reduce CO_2 emissions (www.gestalten.com/myclimate).

myclimate
Protect our planet